# Jewish Cultural Aspirations

## The Jewish Role in American Life

An Annual Review of the Casden Institute for the
Study of the Jewish Role in American Life

# Jewish Cultural Aspirations

## The Jewish Role in American Life

### An Annual Review of the Casden Institute for the Study of the Jewish Role in American Life

*Volume 10*

Bruce Zuckerman, *Editor*
Ruth Weisberg, *Guest Editor*
Lisa Ansell, *Associate Editor*

Published by the Purdue University Press for
the USC Casden Institute for the Study of the
Jewish Role in American Life

*Production Editor*, Marilyn Lundberg

*Cover photo:*
Bill Aron. *Tallit Steps*, Revisited (Moslem Quarter). 2010.
*With permission of Bill Aron.*

Paper ISBN 978-1-55753-635-8
ePDF ISBN 978-1-61249-236-0
ePUB ISBN 978-1-61249-237-7
ISSN 1934-7529

Published by Purdue University Press
West Lafayette, Indiana
www.thepress.purdue.edu
pupress@purdue.edu

Printed in the United States of America.

For subscription information,
call 1-800-247-6553

# Contents

# Foreword

With every *Annual Review* published since I became Director of the Casden Institute for the Study of the Jewish Role in American Life, we have aimed to view the Jewish impact on America and American culture from new angles and from different perspectives. But—until now—this mandate has been more aspirational than literal. Not this time. This is signaled to the reader right away when she or he compares the cover of our tenth volume of the *Annual Review* to the covers of all of the previous volumes. This cover photograph, a panoramic image shot by the noted photographer and a contributor to this volume, Bill Aron, is in *color* rather than the black-and-white images we have always employed in the past. This is intended to make the point—even before you open the cover and go to the first page—that you are going to be looking at more than text in the articles that follow. Indeed, the title for this volume, *Jewish Cultural Aspirations*, must be seen in this light. The aspirations to be considered here are vividly visual and artistic.

In this respect, I can think of no one better qualified to bring this *Annual Review* into the spotlight than the guest-editor who has guided the publication of *Jewish Cultural Aspirations* from its outset: Ruth Weisberg. Ruth has long been a friend and an academic colleague of mine here at USC, whose scholarly and administrative endeavors I have always admired and tried, as best I can, to emulate. But, as is the case with this volume, she brings an added dimension to everything she does, because she is rightfully acknowledged to be one of the finest visual artists of our time. Moreover, she has used her enormous talent to engage themes that are self-consciously Jewish and, through her artistic works she has allowed us to see things about Jewish culture, and especially the role of women in Jewish cultural life, that we might not comprehend without her vision to illuminate them for us. In this volume she has taken the opportunity to paint on a broader canvas by inviting colleagues engaged in artistic efforts complementary to her own work to assess where art in a Jewish context is heading today and in the future.

This leads me to note a curious problem that I encountered as I

copy-edited this volume. As the final copy-editor for the *Annual Review*, I always pore over every word and try to block all errors and to enforce a common style throughout. To be frank, I can get downright compulsive about such minutiae, and it was directly because of this that I began to notice, as I went from article to article, a slight variation in style that gave me pause. It all had to do with how to handle a phrase used frequently in this volume, namely "Jewish art"—or should I say, "Jewish Art"? Depending on who was doing the writing and especially the specific contexts in which this phrase occurred, sometimes the phrase was written as "Jewish art," and sometimes it was "Jewish Art." There were variations on the theme, as well; for example should one speak of "Jewish architecture" or "Jewish Architecture"? This is especially true in an article (as you will see below) where it is the Jewish aspects of architecture that are under close consideration.

The more I thought about it, the more I realized that this was not necessarily a minor matter, easily dismissed. In the lead article for *Jewish Cultural Aspirations*, the eminent art-historian Matthew Baigell makes a bold claim: that—although we may not realize it—we are in the midst of a "golden age" of modern art with Jewish themes. Wonderful, but if this is so, should we not then elevate the status of such cultural aspirations by speaking of them as "Jewish Art" rather than "Jewish art"? Perhaps so, but Prof. Baigell (upon being queried about this) made it quite clear that he prefers the lower case "a." On the other hand, other contributors to this volume prefer "A" in the upper case. So which one is it to be? I went to our guest-editor with this quandary, and asked her to make a decision: Jewish Art or Jewish art? But she wisely proposed that we follow Emerson's advice and not succumb to a "foolish consistency"; rather, we should allow "Jewish Art" and "Jewish art" to coexist. The more I thought about it, the more I realized that this would allow us to make an important point. After all, there is a considerable gray area between art that happens to be Jewish and art that is sufficiently distinguished from other artistic endeavors to be part of a cultural movement worthy of being deemed Jewish Art.

From the standpoint of the individual artist, there is a natural and justifiable desire to eschew any such "either/or" lumping-labeling as overly simplistic. After all, when Monet painted what he imagined in his mind's eye, he did not label his canvases as "impressionistic." This was done by an outside observer—and not a friendly one at that; still, the label, however imperfect, has stuck. Whether art that has self-conscious Jewish themes, which—as the articles in this volume attest, is flourishing on many levels—will ever be known as Jewish Art remains to be seen. In part, it may be argued that this is a question

that this volume of the *Annual Review* is trying, in an open-ended fashion, to address.

We have gone to considerable lengths to make sure that the articles that follow are well illustrated. Not only have we inserted black-and-white illustrations at the most appropriate places in the body of each of the studies, so they can be easily referenced by the reader as he or she progresses through *Jewish Cultural Aspirations*, but we have also included a special color supplement in the middle of the volume that better depicts the works that are in color of the artists who are featured. In this regard, I want to thank our colleagues at Purdue University Press—especially Charles Watkinson and Bryan Shaffer— for encouraging us and supporting us in doing this. Nonetheless, I wish to caution the reader that this *Annual Review* does not feature a collection of fine modern art prints of the type one might expect to encounter, for example, in an exhibition catalogue; rather, this is a book *about* rather than *of* art in a modern Jewish context. We hope that the illustrations in our color supplement will give the reader an opportunity to gain a better sense of the featured art works, but they will not be all they could be, if money were no object. For the reader's reference, we are also establishing a page on the website of the Casden Institute where the art cited in *Jewish Cultural Aspirations* may be found; or, alternatively, directions to where good illustrations may be found on the Internet are noted. Fortunately, nearly all the art featured in this volume can be found on the Web.

The production-editoral work for Volume 10 of the *Annual Review* and the time-consuming task of getting all proper permissions for use of illustrations were particularly demanding this time around. Marilyn J. Lundberg was her usual hyper-competent self in doing the former, and Lisa Ansell, Associate Director of the Casden Institute, invested many hours in the latter. Ruth and I are grateful to you both. Every year, as I write these forewords, I am reminded of how many people share their valuable time to ensure the success of the Casden Institute and of this *Annual Review*, in particular. Of these, Alan Casden always deserves pride of place. It is his expectation of excellence that we all try to meet at the Institute that bears his name. Susan Wilcox, Associate Dean of Dornsife College Advancement keeps a sharp lookout for us in order to ensure that we keep moving forward on a steady and successful course. Others in the USC administration, especially USC's President C. L. "Max" Nikias, Provost Elizabeth Garrett and Vice-Provost Michael Quick, are all stalwart friends and supporters of the goals of the Casden Institute and the scholarly aims of the *Annual Review*, and we are highly appreciative of all their efforts on our behalf.

The Dornsife College of Letters, Arts & Sciences has just welcomed a new dean to lead us forward, and I want to take this opportunity to welcome Dean Steve Kay to his new position and wish him the very best.

When Ruth Weisberg and I were trying to decide to whom to dedicate this volume, we both immediately concurred that one long-time lover of the arts, dedicated supporter of USC and the best of friends to the Casden Institute was the clear choice: Ruth Ziegler. Not only has she done so much to advance Jewish cultural aspirations on our campus and in Southern California, but, as many artists will attest in a wide range of visual arts, film, architecture, etc., she has been the one who has so often enabled their work to become a reality. Besides, I simply cannot be objective about Ruth Ziegler—I just love her and everything about her (and I am just one of many who would say as much and more). So we take enormous pleasure in dedicating *Jewish Cultural Aspirations* to Ruth Ziegler. If we are living in a golden age of Jewish A/art, even though many of us may not realize it, Ruth has long known this to be true—and has helped make it happen.

Bruce Zuckerman, *Myron and Marian Casden Director*

# Jewish Cultural Aspirations:
# An Introduction

## *Ruth Weisberg*

The cultural aspirations and accomplishments of the Jewish people in Europe and the Americas in modern times have been highly significant and of an order of magnitude greater than their numbers in the general population. While this volume will concentrate on contributions to the Arts in the United States, I feel it would be helpful to provide an historical context for the rapid changes that have transpired especially in the late nineteenth and early twentieth centuries. I also wish to note that, while the general context I wish to give in this "Introduction" is relevant to all the Arts, in terms of the essays assembled in this volume of the *Annual Review* of the Casden Institute for the Study of The Jewish Role in American Life, I have favored what I know best as an artist, a Professor of Fine Arts at USC and a writer: namely, the visual arts—especially in their specifically Jewish context. Even though there are aspects of these changes that go back to antiquity, I will take as my starting point the political Emancipation of the Jews in Europe, beginning in the France of 1791.

Over the course of the nineteenth century the Jewish people gradually gained political emancipation, as European countries formally granted citizenship to them. This was a product of the Enlightenment, a cultural and intellectual movement in eighteenth century Europe and America. It signified important gains as well as some losses for the Jewish people. And it was always incomplete in several very significant ways.

Emancipation made its slow progress across Europe, beginning in 1791 in France, and then being adopted, for example, in Sweden in 1835, the United

Kingdom in 1858, Italy in 1861, Russia in 1917, and finally Romania in 1923. It was accompanied everywhere with greater civic and cultural participation by Jewish people, although many barriers and much informal discrimination persisted.

While the "Age of Enlightenment" evokes many familiar names such as John Locke (1633–1704) and Voltaire (1694–1778), there was always a Jewish presence, notably Baruch Spinoza (1632–77) and Moses Mendelssohn (1729–86). A parallel Jewish Enlightenment was called by the term that in Hebrew reflected this sense of enlightened wisdom, namely, the *Haskalah* which advocated integration into European society and culture along with the study of Jewish history and the Hebrew language. One major preoccupation was the desire for increased education that focused on secular studies. Along with this often came a self-conscious rejection of mysticism and traditional midrashic and other rabbinic scholarship and a call to adopt the kind of European culture and thought reflected in a more assimilated lifestyle.

The rise of what came to be called the Reform Movement in Judaism is a direct product of these beliefs and aspirations. However, assimilation did sometimes lead to a diminished sense of Jewish identity and to conversion as well as the loss of certain community-enhancing domains of self-governance such as the *Bet Din*, the rabbinical court of Judaism.

In general the shift from being a separate and discriminated-against minority to being more integrated into the life and institutions of their time, caused many Jews to aspire to wider knowledge of and far greater participation in mainstream western culture. Cities with large and more affluent Jewish populations, such as Paris, Vienna, and Berlin, became especially active in these new arenas of ambition and desire. However, it is important not to idealize the context in which this Jewish cultural awakening took place. Anti-Semitism was hardly a sudden aberration of the Nazi era but an abomination long festering even in places as "enlightened" as the capitals of Europe. In Edmund de Waal's brilliant study of the very wealthy and cultured Ephrussi family of Paris and Vienna (from which he is descended), we get a vivid sense of the kind of endemic anti-Semitism that was always in the background and which emerged dramatically and very destructively from time-to-time (de Waal). For example, the Dreyfus Affair became the quintessential anti-Semitic political scandal that rocked France at the turn of the century. In 1894 a French Army captain, Alfred Dreyfus, who became a target primarily because he was Jewish and dared to aspire to the privileged position of a military officer, was sentenced to life imprisonment, based on doctored evidence. In Paris especially,

the ensuing Dreyfus Affair, caused "seismic splits into bitter Dreyfusard and anti-Dreyfusard camps. Friendships were curtailed, families separated and salons where Jews and veiled anti-Semites used to meet became actively hostile" (de Waal 102, 103).

In describing the effects of the Dreyfus affair on his ancestor Charles Ephrussi, the erudite collector and highly important patron of the French Impressionists, de Waal writes, "Amongst Charles's artist friends, Degas became the most savage and anti-Dreyfusard, and stopped speaking to Charles and the Jewish Pissaro. Cezanne, too, was convinced of Dreyfus's guilt, and Renoir became actively hostile to Charles and his 'Jew art'" ( de Waal 103).

It was not until 1906 that Dreyfus would finally be cleared of all charges, but by that time Paris would be drastically changed even for someone with the status of Charles Ephrussi. In de Waal's words, "He was a *mondain* with doors shut in his face, a patron ostracized by some of his artists" (de Waal 104).

In regard to anti-Semitism in the Austro-Hungarian Empire, de Waal quotes the anti-Semitic English writer Henry Wickham Steed:

> Liberty for the clever, quick-witted, indefatigable Jew [allowed him] to prey upon a public and a political world totally unfit for defense against or competition with him. Fresh from Talmud and synagogue, and consequently trained to conjure with the law and skilled in intrigue, the invading Semite arrived from Galicia or Hungary and carried everything before him. Unknown and therefore unchecked by public opinion, without any "stake in the country" and therefore reckless, he sought only to gratify his insatiable appetite for wealth and power . . . (de Waal 129).

The perception of Jewish insatiability coupled with a lack of loyalty to the homeland nation were well known lies constantly evoked in anti-Jewish screeds. Often the label of "cosmopolitan" was applied to Jews as a code-word for a set of highly negative connotations. Nonetheless, in this complex dynamic of new possibilities, age-old discrimination and mixed messages, Jewish people took significant risks to champion new modes of cultural expression.

In the landmark 1999 publication *Berlin Metropolis: Jews and the New Culture 1890–1918*, Emily Bilski insightfully notes:

> Despite the many opportunities available to Jews during this period, there were still important areas of German public life from which they were excluded, such as the court, the military, the state bureaucracy, and, to a large degree, the universities. Thus Jews tended to

gravitate toward the free professions. Denied access to the official
public spheres, they turned to the less organized alternative public
spheres that characterize urban life, such as the newspaper, the jour-
nal, the art gallery, the café, the theatre, and the political group. At
this juncture in German History, Jews were fully Germans, yet still
social outsiders. The men and women involved in modernism were
members of the transitional generations of German Jewry: far enough
removed from the insular life of the traditional Jewish community,
well-versed in German culture, yet not completely assimilated into
German society (5).

This sense of the marginal status of the Jews deeply affected their at-
titudes and aspirations often to the great benefit of posterity. For example,
Frederic Grunfeld notes: "It was precisely this problematic stratum of 'mar-
ginal Jews'—the so-called *Grenzjuden*—which supplied most of the artists and
intellectuals who helped to create the most exciting epoch in German intellec-
tual history. The very precariousness of their position astride the two cultures
gave them an extraordinary vantage point from which to survey the European
cultural landscape" (5, cited in Bilski 5).

Whether in France, Italy, Germany or Austria the aspirations for what
the Germans called "Bildung" were a hallmark of late nineteenth and early
twentieth century Jewish life. "Bildung" refers to a quest for self-cultivation,
the acquisition of taste and discernment that every individual could and
should pursue. It comes at a moment— just at the turn of the century—when
there was great ambition for cultural attainments, which would only later be
available through a university liberal arts education.

The attraction to new art forms or new roles was especially understand-
able, as these were positions that were more open and welcoming to Jews.
Sometimes, particularly in the realm of theater or cabaret, there was also the
sense of a somewhat disreputable world or demi-monde, which would certain-
ly have seemed inappropriate to a proper gentile family. Jews did not seem to
have the same compunctions and the role call of impresarios, actors, actresses
and promoters are filled with Jewish names. As early film tended to be an out-
growth of theatre, this goes a long way in explaining why early Hollywood was
so dominated by Jewish individuals and families.

There is also the precedent in Yiddish culture of the *badchan* or *bad-
chanim*, the master(s) of ceremonies at weddings, Bar Mitzvahs and Brit Milot
(the circumcision ceremony), who might range in his offerings from a serious
poem for the bride to light-hearted doggerel for the guests. Humor was highly

valued in the often hard lives of the Jews. The "tummler" or jokester, in his role as "life of the party," was always appreciated. It is not at all surprising that the ranks of professional comedians and comic writers have always been well populated by Jews.

Among Jewish artists, performers and presenters, there was a sense both of less to lose as well as an attraction to collective realms, in which they could serve as agents of change and invention. In particular there was an affinity to the new art forms and attitudes that we now call "Modernism." The status of intellectually and culturally adventurous outsider is also present in the United States. One could evoke here names such as Alfred Stieglitz, American photographer and art-promoter who founded *Camera Notes* in 1902, the revered photographic magazine, and the highly influential "291" New York gallery in 1908, or any number of other artists and collectors such as Gertrude Stein and the sisters, Clarabel and Etta Cone, as well as the surrealist Man Ray.

In *Modern Judaism: An Oxford Guide*, Yaakov Malkin, Professor of Aesthetics and Rhetoric at Tel Aviv University, writes of American, European, and Israeli secular Jewish culture as embracing:

> . . . literary works that have stood the test of time as sources of aesthetic pleasure and ideas shared by Jews and non-Jews, works that live on beyond immediate socio-cultural context within which they were created. They include the writings of such Jewish authors as Sholem Aleichem, Itzik Manger, Isaac Bashevis Singer, Philip Roth, Saul Bellow, S. Y. Agnon, Isaac Babel, Martin Buber, Isaiah Berlin, Haim Nahman Bialik, Yeudah Amichai, Amos Oz, A. B. Yehoshua, and David Grossman. It boasts masterpieces that have had a considerable influence on all of western culture, Jewish culture including—works such as those of Heinrich Heine, Gustav Mahler, Leonard Bernstein, Marc Chagall, Jacob Epstein, Ben Shahn, Amedeo Modigliani, Franz Kafka, Max Reinhardt, Ernst Lubitsch, and Woody Allen (107).

While this is an excellent and evocative list, it is singularly devoid of women artists and writers who could have easily been included, such as Sonia Delaunay Terk, Gertrude Stein, Anni Albers, Charlotte Solomon, Emma Lazarus, Louise Nevelson, and June Wayne, to mention only a few twentieth century examples. This list of women, of course, becomes even more expansive the more we approach the current day.

Shifting our historical gaze to America one is struck by similar aspirations in the analogous population. The height of Jewish immigration to the United States was between 1904–10 on account of the pogroms and other

serious anti-Semitic activity in Eastern Europe and Russia. By 1924, two mil-
lion Jews had arrived from Eastern Europe, the vast majority coming in steer-
age. Nevertheless, in just one or two generations the values of education and
hard work had tended to greatly enhance the stature of the Jewish community.
Jews were famously eager to support culture. They wanted to serve on orches-
tra, theater and museum boards; and they began to constitute here as in Europe
a very large percentage of art collectors, artists, musicians, performers, cura-
tors, critics, and film and ultimately television producers. Some of the arts were
more welcoming than others. Both communal and world famous orchestras
have had a longer history of Jewish involvement and participation. In con-
trast, some fields were notoriously more hostile. In Architecture, in particular,
as one of the essays below will specifically consider, almost all architectural
firms tended to exclude Jews, and indeed, it was not easy to even pursue an
architectural education. The account my own father told his children of having
to change his name via forgery, from Avram Weisberg to the more Germanic
"Alfred Weisberg" in 1922, in order to be accepted as an architectural student
at the Armour Institute (now the Illinois Institute of Technology) was one of
the formative stories of my childhood. Even serving on the governing or fun-
draising boards of major secular institutions was highly problematic, as these
institutions of American cultural and social life tended to informally enforce a
policy of excluding Jews. For example, in Los Angeles as elsewhere in the US
there were segregated country clubs. As a result, in Southern California both
Jews and show business types founded their own country clubs—Brentwood
and Hillcrest catering especially to Jews, and Lakeside originally to actors and
other Hollywood people. It took both vision and courage for Dorothy Buffum
Chandler, who was married to *Los Angeles Times* heir Norman Chandler, to
create starting in 1968 the "Amazing Blue Ribbon 400," a prestigious commit-
tee of wealthy women, to support the Los Angeles Music Center. The composi-
tion of the group, encompassing both Jews and gentiles, had a major impact
on integrating Jews and others into the cultural elite of the city. This is not
terribly ancient history and I've spoken about the impact of the "Blue Ribbon
400" (now 500) with several of the first generation of women who were part of
the group.

   Museums such as the Museum of Contemporary Art in Chicago (MCA)
and the Museum of Contemporary Art in Los Angeles (MOCA) have strik-
ingly similar histories. The well-established major art museums in those urban
areas, in this case the Art Institute of Chicago and the Los Angeles County
Museum of Art, were not all that welcoming to Jewish participation in the

early- and mid-twentieth century. In compensation the Jewish elite dominated the founding boards of the two new museums, the MCA opening in 1967 and MOCA in 1980. This is not to suggest however, that MOCA founding Board members, such as Marcia Weisman, Eli Broad or Max Palevsky, for example, had a particular interest in Jewish Art *per se*—to the contrary, they were interested in a Modernism that was more "universal" and therefore broadly inclusive. Nonetheless, their active participation in these major cultural institutions gave Jews a higher profile in regard to the artistic aspirations of the city.

Which is not to say in reference to Los Angeles as elsewhere that there were no institutions with a vested interest in Jewish Art. For example, the Skirball Cultural Center, an outgrowth of the Skirball Museum founded in 1972, which was originally housed at Hebrew Union College-Jewish Institute of Religion, Los Angeles (HUC) adjacent to the University of Southern California (USC) campus, took a leadership role in this regard. Open to the public since 1996 in a beautiful location astride the Sepulveda Pass between the Los Angeles Westside and the San Fernando Valley and just a few miles from the Getty Cultural Center, the Skirball has presented many ambitious exhibitions and retrospectives including ones focused on George Siegel, R. B. Kitaj, and Tobi Kahn, as well as a retrospective of my own work, "Ruth Weisberg, Unfurled" (2007). Very disappointingly, their curatorial staff has recently been greatly reduced, and they seem to have drifted away from their commitment to Jewish Art in favor of more general cultural offerings. One can hope that this is not a permanent change.

Meanwhile the HUC Museum in New York has maintained a very important exhibition calendar under the direction of Laura Kruger. Indeed Jewish museums are thriving all over the United States. The "Council of American Jewish Museums" (CAJAM) lists eighty-six member-institutions in the United States and Canada. While they vary greatly in size and scope, very few major urban centers are without a Jewish cultural resource.

A new development that is very encouraging is the formation of artist-led Jewish groups. While not a totally new phenomena—the American Jewish Artists Club in Chicago was founded in 1928—artists seem to be feeling a greater freedom to express their Jewish identity and are less fearful of appearing "too Jewish." Paradoxically this fear of being, "too Jewish," which was also a product of the universalizing preferences of Modernism, has in the last several Post-Modern decades tended to be enforced more by self-conscious Jewish curators and gallerists than by forces in the non-Jewish world, an issue Richard McBee considers in his essay in this volume.

The Southern California Jewish Artists Initiative (JAI) (fig. 1), which has a juried membership, has grown from twenty-five to almost eighty members in eight years. It has had a very active exhibition schedule as well as an ambitious program that brings Israeli artists to Los Angeles with the support of a Cutting Edge Grant from the Jewish Community Foundation. I and others at USC and HUC, Los Angeles have been inspired by the success of this Israeli program as well as other Israel-based programs and exchanges, to launch a new and very exciting effort at USC. At the request of Provost Elizabeth Garrett, in the Spring of 2012, I launched the USC Initiative for Israeli Arts and Humanities. This effort, under the aegis of the USC Dornsife College of Letters, Arts & Sciences with the full cooperation of HUC and the five Art Schools at USC, has as its charge to extend the University's ongoing interest in Jewish Art to encompass the full panoply of Israeli culture.

*Figure 1. Member Meeting of the Southern California Jewish Artists Initiative (JAI) (Chris Garland).*

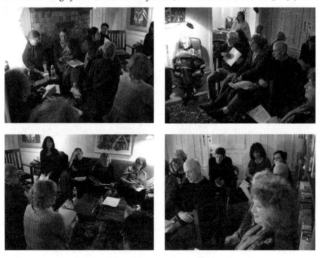

As Victor Raphael and I have written elsewhere, "Reaching new audiences often has unanticipated consequences. It was at a panel of the Los Angeles artists at The L. A. Story exhibition, curated by Laura Kruger of Hebrew Union College-JIR Museum in New York that several New York artists turned to each other and said, 'They're doing this in LA—we should be doing this in New York'. The result of that impetus was the New York Jewish Art Salon" (Weisberg and Raphael 4). Founded in 2008, it has been structured as a more expansive organization, and it now has close to seven hundred members, four hundred of whom are artists. Among the contributors to this volume, Matthew Baigell and

McBee are very active participants. And there are other groups in various cities including Madison, Wisconsin and Denver, Colorado as well as the Jewish Women's Art Network (JWAN), which is an affiliate of the National Women's Caucus for Art.

It is a real privilege to be publishing Matthew Baigell's essay, which asserts that we are living in a golden age of Jewish American Art. Baigell has been the major voice in this arena for many years, having published six books on this topic since 1996. His article not only summarizes this argument but also brings to our attention a broad-based movement in contemporary Jewish American culture which is "distinct, but not entirely separate, from the majority culture" (25). He demonstrates the power and potential for transformation inherent in the accomplishments of a significant cohort of Jewish-American artists.

McBee, who is the most important critic writing about Jewish Art and artists on the East Coast, frames Baigell's assertions in his own distinctive way and goes on to explore cogent related categories such as the American Jewish Museum, and Jewish Artists groups, as well as traditional Jewish modes of expression such as those manifest in biblical and midrashic interpretations. Our youngest contributor, Marcie Kaufman, brings her own generational perspective to these issues. She provides a lively account of what her cohort is doing in their own distinctive way to respond to issues of Jewish identity and observance.

David Kaufman's masterful essay on American Jewish architecture raises fundamental questions regarding whether one can legitimately speak of this as a category unto itself. He states that "the Jewishness of architecture is perhaps better seen as a function of the individual relationship between an architect, his client, and the commission" (71). Kaufman skillfully considers the work of American Jewish architects such as Louis Kahn, Frank Gehry, Daniel Libeskind, and Peter Eisenman, analyzing their groundbreaking work on synagogues, Jewish museums and memorials.

Daniel Magilow's article on Jewish revenge fantasies in recent American films is a provocative take on an important new phenomenon in American cinema. He posits that the value of these films is in their genre-upending scenarios and their status as meta-commentaries, or in Magilow's words, "from the ways in which they satirically or at least self-consciously cite, invert, and overstate conventional cinematic representations of Jews" (92).

We are also honored to have an essay from Bill Aron whose photograph *Tallit Steps*, Revisited (Moslem Quarter) (2010) graces the cover of this volume of the Casden *Annual Review*. Giving Jewish artists such as Aron an oppor-

tunity to share their thoughts, especially in terms of how they came to their artistic decisions, underscores the role of Jewish Art as an alternative form of midrashic commentary, an enduring aspect of Jewish tradition. Not surprisingly, artists are well represented in this volume as Bill Aron, Marcie Kaufman, and Richard McBee are all very active and highly respected artists.

Whether written by artists or scholars, I believe the value of this collection of essays is in its thoughtful and original analysis of artistic expression that reveals how Jewish culture creates meaning and identity.

## Works Cited

Bilski, E. "Introduction." *Berlin Metropolis: Jews and the New Culture 1890–1918*. Ed. Sheila Frieding. Berkeley, Los Angeles and London: Jewish Museum and Univ. of Berkeley, 1999.

de Waal, E. *The Hare with Amber Eyes; A Family's Century of Art and Loss*. New York: Farrar, Straus and Giroux, 2010.

Grunfeld, F. V. *Prophets without Honour: A Background to Freud, Kafka, Einstein and Their World*. New York: McGraw Hill, 1979–1980.

Malkin, Y. "Humanistic and Secular Judaisms." *Modern Judaism: An Oxford Guide*. Ed. N. de Lange and M. Freud-Kandel. New York: Oxford Univ., 2005.

Weisberg, R. and V. Raphael. "Mainstreaming Jewish Art." *A Gathering of Sparks; Jewish Arts Initiative 2004–2011*. Ed. A. Hromdaka. Los Angeles: Jewish Arts Initiative, 2011.

# We Are Living in a Golden Age of Jewish American Art and We Really Don't Know It*

*Matthew Baigell*

I

Most people do not realize that we are living in a golden age of Jewish art in America. But we are. Beginning in the 1970s, artists all over the country have started creating an amazing number of works based on the Bible, the Talmud, Kabbalah, Jewish legends and *midrashim* (explanations of and elaborations on biblical texts usually associated with rabbinical commentaries), the daily and High Holy Day prayer books, as well as certain contemporary events in Jewish history. This is happening now more than at any other time in the nation's history. Moreover, this is a golden age with a difference. Rather than illustrating episodes in the lives of biblical figures in traditional ways or presenting stereotypical genre scenes such as grandma lighting the Sabbath candles, dancing hasids, or, say, tacking on a Star of David (just to leave no doubt that a given work of art has a Jewish theme), artists today have found new artistic approaches that have no inhibitions about questioning what they can discover within a Jewish context. Depending on their points of view—feminist, psychological, existential—they approach their subject matter in entirely different ways that distinguish them from past artists as well as from each other.

These artists, the ones who search out and challenge subject matter derived from ancient texts and traditions are—for me—the most vital and interesting artists of our time, the ones most willing to take risks with their material

as they open up new ways to create art that has Jewish religious content. So, I will assert that these artists make up the current avant-garde in Jewish American art and are the most important artistic contributors to contemporary Jewish American culture.[1]

We do not know as much as we should about their work because most of it flies under the radar of art historians, art critics, and curators who, for whatever their reasons, have ignored or neglected their existence. Nevertheless, these artists persist. Styles range from the representational to the abstract, and modes of presentation include cartoon and commix imagery. Many hope that their art contributes to a sense of *tikkun 'olam*, or "repair of the world," and almost all have created narrative cycles based on the lives of individuals or particular episodes in the Bible. These cycles are a recent development, dating only from the 1980s. The artists make use of post-modern modes and formats that include performance activities and the use of found objects, but they are anything but post-modern in attitude. By the designation, "post-modern," I mean an artistic mode of expression that uses intentional irony, dislocated or ambiguous meanings, lack of responsibility for completion of a work, purposeful illogic, and willful miscommunication. In contrast to this, the artists I have in mind abjure any kind of dissembling and prefer instead to communicate directly and straightforwardly with their viewers. They are post, post-modern in that they assume moral positions and openly reveal their spiritual and religious values. Further, many maintain a post-secular attitude in that they have rejected the insistent secularism of twentieth-century art for one based on ancient religious sources.

Two statements by contemporary historians explicate the contours of my argument. First, literary historian Julian Levinson made an important point in his book, *Exiles on Main Street: Jewish American Writers and American Literary Culture*, when he noted that figures such as Gertrude Stein, Lillian Hellman, Arthur Miller, and Norman Mailer did not "evince any particular inclination to return to Jewishness," or have much to say about "the ways in which Judaism and Jewishness have been reimagined and reconfigured" (4). In contrast, authors such as Emma Lazarus, Ludwig Lewisohn, Alfred Kazin, and Irving Howe, among others, did embody such qualities in their writings. The artists whose works I want to discuss have been exploring the ways in which Judaism *can* be reimagined and reconfigured.

The second author, cultural historian Stephen Whitfield emphasized through his book, *In Search of American Jewish Culture*, the importance of Judaism over Jewishness. He said: "Only religion can form the inspirational

core of a viable and meaningful Jewish culture. . . . There is simply no longer a serious way of being Jewish—and of living within Jewish culture—without Judaism" (224, 237). I would not deny the importance of other aspects of Jewish culture, but Whitfield states upfront that, without religion at the center, all the rest is sociology; that, in effect, bagels-and-lox Sunday brunches, visits to parents and grandparents in retirement communities, and Jackie Mason's and Sarah Silverman's jokes are interesting cultural phenomena but are hardly central to Judaism.

I will describe briefly here the artists I admire and respect; and, after looking at a handful of representative examples, I will have more to say in my conclusions.[2] They were born between the 1930s and the 1970s. They are too young to have shared directly in the experiences of the immigrant generations early in the twentieth century or of those who lived through the Depression of the 1930s. They were not yet adults, some not even born, during the years of the Holocaust. Unlike earlier artists, they have grown up in an environment largely free of virulent anti-Semitism. They are also assimilated Americans who have chosen not to give up their Judaism. Rather, they identify positively with it, exult in it but also find that they must often wrestle with it. They go to synagogues, join *havorim*, and study individually with rabbis. Some are quite observant; others, less so; but certainly they all have spiritual values that they are only too happy to share with their viewers. Several have recently banded together both in Southern California and in the New York regions to explore Jewish identity and what it means to be an artist who identifies with the religion and culture of Judaism in the contemporary world. The existence of their organizations, the Jewish Artists Initiative formed in 2004 on the west coast and the Jewish Art Salon in 2008 on the east coast, are impossible to imagine before the 1980s. As readers of this essay will discover, this sense of the late 1970s and early 1980s as a defining period of significant change is one of the touchstones of this exploration of Jewish art.

Because many artists work independently, there have been no obvious chronological, stylistic, or thematic developments. Rather, a happy anarchy has been the rule with regard to attitude, approach and subject matter. Their scope is wide and quite varied and encompasses comprehensive accounts of Jewish history and the various Torah portions; women as outsiders, victims, and hero- ines; close examinations of particular biblical episodes; the creation of actual physical spaces for meditation and contemplation; and, of course, moral is- sues. Aspects of Jewish history have also served as starting points for journeys through their own imaginations. On balance, one might say that the artists'

points of view have been primary, which they then connect to ancient texts and contemporary rituals.

<center>II</center>

A particular case in point will illuminate what I mean. The New York-based Archie Rand (b. 1949) completed a series of paintings of rabbis in 1985; of particular note among these is a work entitled *Rabbis II* (fig. 1; Pl. I). We see a group of rabbis passing by on a street. On the table behind them, a candle, a glass, and a decanter suggest ritual activity. Rand has said that he likes rabbis but respects those who deserve respect. They are no longer necessarily the awesome arbiters of religious doctrine and might be average people one might pass on the street (Goodman 34). It is this attitude that dominates his subject matter, not the other way around, a point of view not generally articulated before the 1980s.[3]

*Figure 1. Archie Rand.* The Rabbis II. *1985. Oil on canvas, 58 x 48 in. Courtesy of the Jewish Museum, New York.*

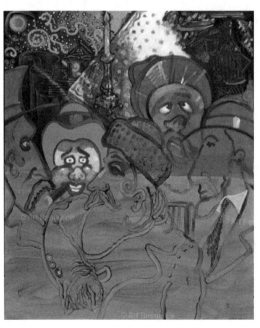

However, there are anticipations of this attitude during the 1960s in certain works by Ben Shahn (1898–1967) and Leonard Baskin (1922–2000), ancestor figures of many contemporary artists—not so much because of their stylistic influences, but rather more because of the ways biblical subjects served as points of departure for their personal statements. For example, Baskin's woodcut portrait of *Moses* (1960) is composed of two parts;[4] a passage written in Hebrew, which takes up the entire right side of the woodcut, relates that Moses is about to see the vision of God in the burning bush (Exodus 3). This passage represents the Jewish Moses. On the left, a portrait of Moses reveals a sad-eyed, disheveled figure seemingly discomfited by the horns protruding from his head.[5] This is the Moses co-opted by Christians. He is no longer Jewish. Baskin seems to be saying that the Moses on the right is *our* Moses, the Jewish one embodied, as it were, in the biblical text. The other one is *their* Moses— a graphic reflection of the mistranslation of the horns for the radiance of Moses' face. My point is that Baskin did not so much illustrate an episode in Moses' life, but rather used him as the point of departure for an artistic statement about Jewish-Christian relations and about the disputed ownership of the Jewish Hebrew Bible/Christian Old Testament, and about his own feelings concerning these matters. In a work such as this, Baskin's feelings are the main subject.

Connecticut-based Janet Shafner (1931–2011), one of the more senior artists I am considering here, was an observant Jew. She created many kinds of works including a long-running series on the triumphs and defeats (including dismemberment and murder) of women, as recorded in the Bible. Perhaps as a result of reading about so much biblical mayhem and having lived through and witnessed times when extraordinarily senseless acts of murder, violence, and destruction have occurred, she seems to wonder if humanity can ever redeem itself. Like other artists, who find many parallels between present day reality and what was recorded in the ancient texts, Shafner invites her viewers to ponder the contemporary relevance of the Bible. As she has said,

> I found that the dramatic lives of our biblical ancestors were strikingly contemporary, and I was fascinated by the connections. Everything that touches us deeply today has a parallel occurrence in the Bible— family jealousy, sexual obsession, enduring love and sacrifice, murder, rape, incest, man's inhumanity to his fellows, even ethnic cleansing— it was all there (3).

Among her most powerful and poignant works concerning the possibility of human sin and redemption is *Adam and Eve: The Sparks* (1999) (fig. 2; Pl. I).

*Figure 2. Janet Shafner.* Adam and Eve—The Sparks. *1999. Oil on canvas, 58 x 50 in. Courtesy of the Artist.*

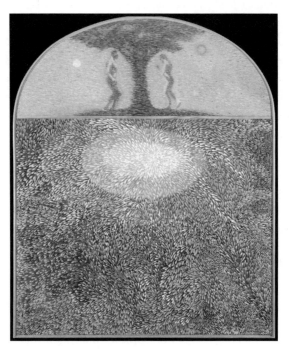

This painting simultaneously combines the beginning of human time, as recorded in Genesis 2ff. in the story of Adam and Eve with the beginning of cosmic time as imagined by the kabbalist, Rabbi Isaac Luria, in the sixteenth century CE, who envisioned in Genesis 1:3 the shattering of the vessels of light at the first moment of Creation. This double-depiction of creation, concurrently on a human and cosmic scale, also hints at the potential for disaster. Adam and Eve appear in the lunette illuminated by the sun and the moon. The biblical Tree of the Knowledge of Good and Evil that separates Adam from Eve reminds us that soon there will be trouble ahead. This sense of foreboding is reinforced by the brilliant colors of the many hundreds of brushstrokes that represent Rabbi Luria's belief that at the moment of Creation, there was such commotion that the divine light contained by the vessels broke free, scattering light everywhere (cf. Scholem 265–68). The idea Shafner wished to portray

was that returning the light to the vessels would take place only after people conducted themselves morally, among other things, and thus Creation could be complete and the Messiah would arrive. So, this ambitious painting's representation of the first humans, Adam and Eve in the Garden, juxtaposed with the first moment of divine Creation, foreshadows on two levels the introduction of evil into the world.

Shafner, in her combination of the biblical and kabbalistic stories, locates Adam and Eve as actors in a cosmic scheme of creation, destruction, and—maybe—redemption. According to Rabbi Luria, Adam compromised Creation by eating the forbidden fruit. To restore the light to its former glory, individuals would have to lead a moral life (Scholem 279–80). But, for Shafner, redemption for humanity is not certain in spite of the painting's bright, sparkling colors. The lights are so shattered that perhaps putting them back in the vessels and thus completing Creation and the arrival of the Messiah, might be impossible.

It is worth noting here that Archie Rand handled the inception of evil in the Garden of Eden in a different, equally ominous yet funny way. In a panel from his series, *60 Paintings from the Bible* of 1994, Adam, who had already eaten the forbidden fruit, turns to Eve and in a cartoon bubble yells out the words—"we're naked!"[6] This alludes to Gen 3:7–13 and especially vs. 11, where God asks Adam how he came to know he was naked—meaning that Adam now realizes that he no longer lives in a state of innocence in the Garden of Eden but has sinned. Adam and Eve appear shocked, surprised, and perhaps not yet fully aware of the seriousness of their predicament. They are all too human and, as humans, perhaps incapable of ever finding their way back to the Garden. Despite Rand's cartoon-like style, his underlying message is as grim as Shafner's.

Again, neither artist was just illustrating a scene based on ancient texts—a double-scene with the kabbalistic elements in Shafner's painting—but rather each used the scene to make a general comment about the nature of humanity and about the present world situation. The questions they raise are these: Are we moral failures as people? Is redemption possible? Yes or no?

The same questions are raised by Chicago-based Ellen Holtzblatt, but in a more personal and revealing way through her images based on the story of Noah and the Flood (Gen 5:28–9:28). Before considering her work, it should be said here that, because narrative cycles by Jewish-American artists are a recent development, there are no canonical scenes that must be included as, for example, would be the case for a series describing the life of Jesus.

Holtzblatt's *Hamabul* or *The Deluge* (2005) consists of fourteen woodcuts

(fig. 3; Pl. II). In an exchange of emails, she explained that the series is a *mi-drash* based on the Flood, in which she reveals her intimate thoughts about life and death, birth and rebirth, and her "connection to the story as a woman who has experienced cycles of fertility and sexuality." Making the woodcuts was, as she said, "a vehicle for learning about myself and the world." It provided her with a way to meditate on the meaning and purpose of her own life. Again, this could not have been done so openly, if at all, before the 1980s.

*Figure 3. Ellen Holtzblatt.* Hamabul: The Earth Became Corrupt Before God. *2005. Woodcut on Japanese Paper, 7 ½ x 14 in. Courtesy of the Artist.*

She found the biblical story riveting but also "spare and emotionless." A wrathful God punishes sin and human corruption but nevertheless allows mercy to triumph over his harsh judgment. However, this biblical account leaves blank details that her imagination has had to fill in. She saw the story less in terms of bad versus good or retribution versus forgiveness and more as a story with intertwined aspects of creation and destruction, and death and rebirth. For her, the Flood remains the ultimate *mikvah*, or ritual bath; for in it she symbolically felt that she could return physically and spiritually to God, to submerge herself in God, and to reemerge as if newly born.

In *Corruption*, based on Gen 6:11, she visualized a corrupt and lawless earth as a pile of bodies with their "gaping orifices freely admitting the seas into their bodies, boundary-less with the waters." It is as if they were being simulta-neously destroyed and reformed in the water. The last woodcut in the series, *All the Days of the Earth*, based on Gen 8:22, marks both the end of the Flood and God's promise never to destroy every living thing again. Holtzblatt portrayed

this in the form of an androgynous being lying on his/her back nursing a newly born child who symbolizes physical and spiritual renewal and the continuity of generations.

For the artist, then, the waters of the Flood signify purification and re-birth, a call to each person to take advantage of the second chance given by God to become a better individual, to build a better world and, thus, to be redeemed. Her series relates to paintings and photographs of *mikvah* scenes, which would never have been exhibited or published in books before the feminist movement began in the late 1960s.[7]

At the same time, her attitude, as well as that of other artists, echoes the conclusions reached in a recent study commissioned by the synagogue consultancy, "Synagogue 3000," which determined that younger Jews are more spiritually and less ethnically inclined than their elders (Harris 11). Their quest, no less than the artists I'm considering here, is less for community than for meaning and purpose in life. In the ancient texts, they find existential issues with which to grapple as well as reminders of their Jewish heritage.

Holtzblatt's narrative series is obviously a confession about her beliefs, her hopes for the world, and her relationship with God. It is impossible to imagine, say, Philip Guston or other older artists being so open about their religious beliefs. Other contemporary figures have also found in biblical texts ways to confront and to resolve various religious and personal issues. One of the most poignant examples is that of New York based David Wander (b. 1954), who explored his own confrontation with God through the story of Jonah (fig. 4; Pl. II). Like many others of his generation, distressed by God's abandonment of His people, wondering what it meant to be Jewish, and finding no spiritual nourishment in organized Judaism during the 1970s, he became interested in Zen Buddhism, Kung Fu and Tai Chi martial arts as well as Native American rituals. At that time, a non-Jewish spiritual teacher, knowing that he was a born student, suggested that he stop shopping the world's religions and philosophical systems and turn to his own religion for metaphysical enlightenment. He did so, and began and still continues to study Jewish religious texts.

During the mid-1990s, Wander found that Jonah's existential dilemmas, as set down in the Book of Jonah, reflected his own search for and ultimate reconciliation with the Jewish God. After studying with a rabbi for a year, Wander found in Jonah a surrogate for his own search, and we can follow their joint paths through 16 ink and watercolor panels entitled *The Drawings of Jonah* completed in the late 1990s. The first thirteen are connected in the form of a fold-out book that describes Jonah's initial rejection of God's command to

go to Nineveh to "proclaim judgment upon it" (Jonah 1:2) and Jonah's (and Wander's) ultimate acceptance of God's will as recorded in the Bible and in many legends that "explain" Jonah's actions.

*Figure 4. David Wander.* The Drawings of Jonah: The Word Came to Jonah. *Early 1990s. Ink and water color on paper, 20 x 41 in. Courtesy of the Artist.*

The first panel, *The Word Came to Jonah*—the title taken directly from Jonah 1:1—reveals Jonah in profile as being quite disturbed and perplexed about his assignment to go to Nineveh, seen in the middle distance. His face records that moment of fear, anxiety, desperation, and helplessness when he asks himself; "what am I to do?" He does, of course, ultimately do God's bidding and goes to Nineveh.

For Jonah, as for Wander, he could either run away from his destiny, from God, or accept responsibility for one's fellow humans and, in addition, accept God who provides life with purpose. The answer ultimately was to accept. Wander concluded that because God created everything, including good and evil, his energy was all pervasive and far beyond finite human comprehension. One must simply come to terms with the presence of God in one's life and, in effect, become a partner with God in sustaining life and living out God's will as he, Wander, assumed Jonah did or else he would not have gone to Nineveh.

The final image of *The Drawings of Jonah* attests to Wander's decision. In it, one sees an almost completely closed circle, symbolic of God's totality. Wander chose not to close the circle perhaps because, like Abraham and Job as well as contemporary individuals, he still reserves the right to make his own decisions or perhaps is still uneasy over the decision that he has already made.

The panel also includes a living and a dead tree indicating God's control over the giving and the taking of life (cf. Jonah 4:6–7).

Another series, this one by New York-based artist Jill Nathanson (b. 1955) entitled *Seeing Sinai* (2004–06) might also have raised eyebrows thirty years ago. But unlike David Wander, she will use only abstract shapes. She has told me that as a person and an artist she searches for connections between what she terms good art and human merit (Baigell, "Abstraction and Divine Contemplation" 14–15). She finds the Torah to be the major connection between the two, in that one can live a life of merit by adhering to the spirit of the Torah and that one can find in the Torah magnificent subjects upon which to reflect, an open admission impossible to imagine by almost any artist born after the immigrant generation and before hers. In effect, Nathanson wants to combine her art with religious spirit, to infuse what might seem to be casually arranged pictorial shapes and objects with strong subjective, religious qualities.

Working with Arnold Eisen, chancellor of the Jewish Theological Seminary, who wrote his own *midrash* on the series, Nathanson planned to recreate in abstract forms, exuberant colors, and rapid-fire brushstrokes the emotional feelings Moses might have felt when he ascended Mt. Sinai the second time to receive the new set of tablets and to talk directly to God (fig. 5; Pl. III). The work illustrated here, *When My Glory Passes I Will Place You*, refers to the emotionally laden moment when God tells Moses that he cannot see his face, but he will shelter Moses in a cleft in a rock while his divine presence passes by (Exod 33:20–23). Nathanson also tried to imagine her feelings if she had spoken to God. After all, not only would she be in God's presence but she would also observe the most generative moment in all of Jewish history—receiving the Torah at Mt. Sinai. The last panel in the series is titled *They Were Afraid to Come Close to Him—He Put a Cover Over His Face*. Through its bright and broad swaths of light greens, yellows, and oranges, it is meant to suggest Moses' (and Nathanson's) excitement as Moses, his face radiant, descends from Sinai with the tablets.

*Figure 5. Jill Nathanson.* Seeing Sinai: When My Glory Passes I Will Place You . . . *2004. Acrylic on Canvas, 54 x 54 in. Courtesy of the Artist.*

Nathanson hopes that the panels might prompt the viewer to meditate upon the events that took place on Sinai without visualizing them in the stereotypical form of some bearded guys in robes and sandals who probably, as is too often the case in the movies, speak with affected English accents. Here, Nathanson has taken the events recorded in the Torah and tried to express them as primal, gut-level experiences mediated only through colors and shapes.

Apropos of *Seeing Sinai*, Nathanson has said, "art is an expression from the depths of human experience or of some kind of purity or untrammeled kind of human experience. It is an attempt at stating or alluding to something qualitative about human experience through something in visual art that we see" (unpublished ms.). The religious leader, Abraham Joshua Heschel, evoked a similar feeling when he wrote:

> The higher goal of spiritual living is not to amass a wealth of information, but to face sacred moments. In religious experience, for example, it is not a thing that impresses itself on man but a spiritual

presence. What is retained in the soul is the moment of insight rather than the place where the act came to pass (6).

In these paintings, it is that pure moment of insight that Nathanson sought to capture.

Connecticut-based Robert Kirschbaum (b. 1949) is also an abstract artist, but his forms are serene, calculated, intellectual, and no less laden with spiritual meaning than Nathanson's more emotional and colorful shapes. For the last thirty years, his subject has been the Temple Mount and the Temple in Jerusalem as an ideal form of perfection (fig. 6; Pl. III). He feels that the Temple is also the most potent symbol of a religion that has largely eschewed representation and, further, that it stands in the mind's eye as a shelter for the spirit and as a model of Heaven. Kirschbaum holds that the Temple represents artistic creation—and his own creative work becomes the means for his virtual rebuilding of the Temple. In other words, the Temple Mount and the Temple are subjects for broad-based idealization, contemplation, and meditation (*Temple*, unpaged).

*Figure 6. Robert KIrschbaum. From the* 42-Letter Name. *2010. Letterpress relief print, 8 x 5 in. Courtesy of the Artist.*

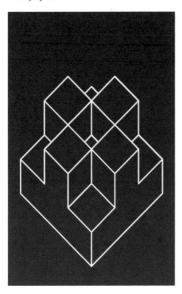 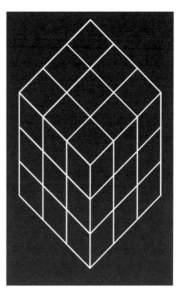

Kirschbaum holds that, as one passes through the portal and the body of the Temple in his or her imagination, one accesses higher realms of being. As he has said, at the core of his images of the Temple there lies the "notion of

the ineffable, an attempt to glimpse the unattainable" (Kirschbaum, Letter to Baigell). He is ever mindful of historian Bernard Goldman's observations that the portal to the Temple serves as an ideal symbol of transformation, metamorphosis, revelation, rebirth, and regeneration. On the other side of the portal lies the hope of "perfect understanding, transfiguration, and eternity." Passing beneath the lintel is "an act of consecration" (Goldman 21). In short, Kirschbaum is among those who try to access the mystical stream through Jewish sacred texts.[8]

Kirschbaum traveled in South Asia and was especially taken by the texts of the *Vastusutra* and the *Mayamata* that addressed matters concerned with Hindu religion, philosophy, and especially the symbolism and composition of architectural forms (Boner, Śarmā and Bäumer; Mayamuni and Degens). And as was the case with Wander, it was Jewish texts that became central to Kirshbaum's religious and artistic interests plus the works and ideas of the Russian Jewish artist, El Lissitsky and the Jewish American, Louis Lozowick.

His suite of prints entitled *The 42-Letter Name* (2009) taken from *The Devarim Series* illustrates, as few other works can do, the serious level of his dedicated and time-consuming research, the profound thought, and the Talmudic ability to connect disparate ideas that several artists have undertaken before commencing a particular work or narrative series. From *The Devarim Series*, Kirschbaum selected forty-two drawings to form the suite that sums up his spiritual connection to the Mount. We see in this double illustration a nine-square, three-dimensional cube and another cube from which individual units have been removed. The cube represents an ideal, completed form—the Temple—and the incomplete cube stands for the fragmented world in which we live. By subtracting one or more squares from the cube, Kirschbaum shows "fragments" of the cosmos, which, when re-assembled would become the whole or complete cosmos, symbolic of the Temple rebuilt in messianic times—an image of perfection and of *tikkun 'olam*. *The 42-Letter Name*, then, is about hope for the future of humanity.

Now, if Kirschbaum were to arrange the cube or any of its parts in perspective, then his symbolic representation of the Temple would appear less ideal, as if it were in our physical world, in our space. He was probably reminded of Stanley Tigerman's observations that reconstructions of the Temple, especially those based on Ezekiel's descriptions (ch. 43), were usually organized around a nine-square, geometrically simple grid in order to remove it "from the particularities of a site. This act of displacement allows exploration without regard for [a] realistic setting" (96).

To solve the problem of preventing the imaginary Temple from entering into our human space, Kirschbaum decided to use axonometric projections for the various cubes that make up the *Forty-Two Letter Name*. In this kind of projection, receding lines remain parallel and do not meet at a vanishing point. As has been pointed out, axonometry represents "an unrepresentable infinity, . . . axonometry makes one reflect on (and no longer *see*) infinity" (Bois 172–74). So, all spatial representation as perceived in the real world is eliminated, thus denying the viewer the ability to fathom what is near or far, here or there. Kirshbaum took this idea from El Lissitsky who wanted to abolish any sense of physical location and even gravity in his work. So, the forty-two prints, made up of white lines on black backgrounds, can be read both two-and three-dimensionally which also reflects Kirschbaum's ongoing search for the invisible God as well as imagining a completed and whole cosmos (equivalent to the full cube).

But why the title *Devarim*? First, *Devarim* is the Hebrew designation for Deuteronomy, a book composed primarily of three discourses by Moses, the first one of which is called *devarim*. A scroll found on the Temple Mount during the renovations sponsored by King Josiah in the late seventh century BCE (cf. 2 Kgs 22:8ff.) has been associated with the Deuteronomic text and therefore with Moses as its author (Mazar 12; see also Deut 31:24; and the discussion of 2 Kgs 22:8 in Berlin and Brettler 770–71).

Second, the word, *devarim*, is also associated with the *Shekhinah*, one of the kabbalistic *spherot*, or emanations of God most closely associated with humans (Matt 224).

Third, as Rabbi Kenneth Brander, dean of Yeshiva University's Center for the Jewish Future has noted, according to the Talmud, Deuteronomy is considered a Second Torah because Moses presumably wrote it. Rabbi Brander then suggests that because of this connection, Jews, like Moses, must play an active role in their relationship with God. One way is to write a Torah of one's own in order to repair the world and complete Creation (Brander 18–19). This is precisely what Kirschbaum has done by suggesting in visual terms an idea about perfection, echoing the theme of *tikkun 'olam* that, as we have seen above, is a major concern of the artists we are examining in this study.

Fourth, it is held that God created the Foundation Stone over which the Holy of Holies of the Temple was built and then engraved the first letter of each word of what became the forty-two-word prayer from which he created the world (the following is based on Matt, *The Zohar: Pritzker Edition* II, Section 71a; Patai, *Man and Temple* 57–58; Alexander 120–25; Idel 89; Tishby

and Goldstein II, 361; Townsend 310). The prayer, the *Ana B'koach*, recited near the start of Sabbath services, is reputed to have been written by Rabbi Nehunya ben ha-Qanah in the second century CE (the prayer can be found in Schermand and Zlotowitz 314).

Fifth, there is also the suggestion in the *Zohar*, one of the principal books of Kabbalah, that the Name consists of the first forty-two letters of the Torah. But this can be understood only through a process of encoding that, lost to succeeding generations, was known only to the ancient "academy."[9]

When these explanations are conjoined, it is no wonder that Kirschbaum found ample material in the Bible, the Talmud, Kabbalah, legends, and synagogue ritual to create this series centered on the most sacred space in Judaism.[10]

Like Holtzblatt and Wander, several artists have found in biblical figures mirrors of their own concerns and have looked for contemporary meanings in the ancient stories. The lines separating one artist from the other, to be sure, are not sharp, but distinctions can be made. New York-based Tobi Kahn (b. 1952), among the most conservative in attitude, stays closer to the biblical text than others, yet he, like Jill Nathanson and Robert Kirschbaum, while using abstract forms, will give just enough narrative hints to make them understandable.

For example, in 2007, Kahn created panels for the backs of four chairs, entitled *Shalom Bat Chairs*, to be used in the ceremony for naming girl babies (fig. 7; Pl. IV). The panels honor the four Mothers of Genesis—Sarah, Rebecca, Leah, and Rachel. In the panel honoring Sarah, second from the right, two large blue forms separated by a thinner yellow form signify both closeness and distance between Sarah and Hagar. Sarah is depicted by the figure on the left. Her head is thrown back because, when she found out that at the age of ninety she would have a child, she laughed to herself (Gen 18:12). The red area between her legs suggests blood, symbolizing life and the birth canal for her son, Isaac. The blue color of the two women might also symbolize water, continuity, purification, and the flow of time. In comparison to Hagar's figure, Sarah's upright posture gives her a noble, royal bearing, appropriate to her position as the mother of the Jewish people and, with Abraham, the parents of a nation (Gen 17:40).

The spiky, up-and-down, red-brick forms in the Rebecca panel, second from the left, probably symbolize the personal difficulties Rebecca encountered in raising two quite different sons, Jacob and Esau, as well as the personal turmoil involved in convincing Isaac to bless Jacob in place of Esau. After all, when Isaac in his old age wanted to bless his sons, it was she who planned to substitute Jacob for the first-born. The open mouth-like form on the upper

right might suggest Rebecca's interference in the lives of her sons. And the vertical form rising the length of the painting probably alludes to Rebecca's desire to keep the boys apart. The triangular, sharp-edged wedge in the upper left could be a stand-in for Esau, reflective of his personality, and the softer rounded form in the lower right might represent Jacob. In any event, of the four paintings, this one elicits the greatest sense of discomfort, an appropriate response by Kahn to the most complicated of the founding mothers.

*Figure 7. Tobi Kahn.* Shalom Bat Chairs—Rachel, Rebecca, Sarah, Leah. *2007. Acrylic on wood, 41 ¾ x 45 ¾ in. each panel. Courtesy of the Artist.*

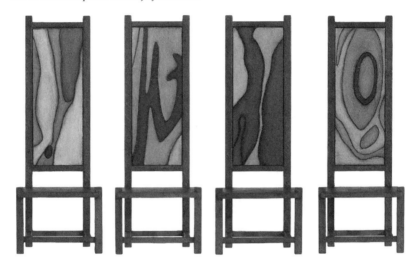

Leah's power lay not in her devious actions but in her fertility (the panel on the right). Kahn represents the unloved wife of Jacob who gave birth to six sons by the large womb-like form in the center. The thin line at the bottom that traverses the painting represents an umbilical cord, and the curving forms between suggest amniotic fluid.

And Rachel, Jacob's beloved (the panel on the left), is represented by one of Kahn's most erotic creations—if one imagines that the red circle at the bottom is an egg in Rachel's vagina and the darker blue form descending (penetrating) from the upper right is Jacob's penis.

Beginning in the 1970s, Richard McBee (b. 1947) has, by comparison, raised issues, asked questions, and brought in collateral material in his narrative cycles devoted to the lives of Queen Esther, King David, Ruth, Jacob, Joseph, Judah, and Tamar. But the biblical episode he has explored most extensively is the *Akedah* (Genesis 22), the "Binding (of Isaac)," on whose subject

he has made over eighty paintings including a sub-set on the life of Sarah. His sources include the Bible, and midrashic legends as well as the current scholarship concerned with psychological, inter-generational, existential, and ritualistic matters.[11]

For example, he has projected one image of Abraham as a large, monstrous, zombie-like, inhuman figure who does not communicate on any level with a dwarfed Isaac who tries to catch his attention. The source of this image lies in Julian Jaynes' *The Origin of Consciousness: The Breakdown of the Bicameral Mind*, in which the author held that before a certain moment in human history people had no sense of self-consciousness or free will, that an outside force controlled their activities. He calls this the action of the bicameral mind.[12] In this painting, Isaac's is the cry that cannot be heard, the cry without sound. At the other extreme, McBee invented his own *midrash* concerned with Sarah's death, based on the daily morning prayer. In the first part of a double-painting, the angel of death approaches Isaac, but as a result of God's decision to save his life, the angel, in the second part of the painting, veers off, heading for Sarah who awaits her demise.

*Figure 8. Richard McBee.* Sacrifice. *2003. Oil on canvas and collage, 20 x 24 in. Courtesy of the Artist.*

In other works, McBee explores the complexities of the relationships between the key figures as well as the psychological state of each individual. In *Sacrifice* (fig. 8; Pl. IV) the altar is at the left, and at the center a jumble of brush strokes that suggests the tumultuous emotions raging in Isaac's mind as he tries to balance the intentions of his father with his rescue from a near-death experience. On the right, Isaac crouches, his arms and ankles still bound as if he had just tumbled to the ground. The questions McBee raises are these: given Isaac's traumatic experience, will he ever regain his mental equilibrium and will he ever lead a normal life? Will he always be "bound" in one way or another? When McBee began his initial explorations of the Binding, he said that he was confused by the story. After some thirty years of further reading and study, he says he is still confused, but at a deeper level. He wants to know why God would subject the first Israelite family to such punishment?

Sarah is a popular figure among contemporary artists. New Jersey-based Siona Benjamin, a woman of color, a feminist, and a student of Judaism who was born and grew up in Mumbai, India, often paints women as outsiders. One of her more telling works, completed in a style based on the delicate contouring and bright colors of Indian and Persian miniatures, is entitled *Finding Home #61: Beloved (Fereshteh)* ("*fereshteh*" is Urdu for angels). It portrays the insider, Sarah, and the outsider, Hagar, embracing each other despite the relevant passages indicating, to the contrary, their enmity toward one another in Genesis 16 and 21. Benjamin hopes that this enmity between the women, obvious surrogates for Israelis and Palestinians, will end soon, but the male figures in the right and left margins suggest that the artist knows otherwise. Those on the right, Palestinians intending mayhem, extend a friendly hand but have bombs attached to their bodies. Those on the left, well-intentioned Israeli amputee-soldiers, will be unable to stop the expected carnage. So, the subject here is both what might be—peaceful co-existence—and what is—continued warfare.

New York-based artist Carol Hamoy, a pioneer feminist, has created works in praise of women in the Bible, sometimes with great seriousness and sometimes with tongue-in-cheek. But whatever the subject, she remains among the more dedicated feminists. A few of her comments will make this point very clear. On one occasion, she wrote, "My work is about life viewed through an acquired feminist lens. Rarely are a wife, mother, daughter, or sister mentioned in Torah. Jewish women's historical importance is not emphasized in our tradition. My work is an effort to change that tradition and make visible the invisible part of the children of Israel" (Cover, *Bridges*). In a statement concerning a work with that exact title, *The Invisible Part of the Children of Israel*

(early 1990s), composed of one hundred dresses made of transparent vinyl and suspended in close formation from the ceiling along with more than fifty text pages listing the names and/or accomplishments of almost four hundred women mentioned in the Torah, she wrote, "We cannot rewrite Torah (nor do I expect we should), but we have an obligation to inform our daughters (and our sons) of the important parts our foremothers played in Jewish history" (unpublished statement). Hamoy understands that personal freedom and justice pertains to all humanity. In 1991, for instance, she wrote, "The issues I address in my work are without gender. It is the sibling, not just the sister who interests me; the child, not just the daughter. Although I illustrate my personal experience as a woman, I want my art to speak to anyone who has ever been a parent, child, sibling, lover, or friend" (*Carol Hamoy: Voices* 9).

*Figure 9. Carol Hamoy.* Queen Jezebel. *1993. Mixed media, 18 x 7 ½ x 4 ½ in. Courtesy of the Artist.*

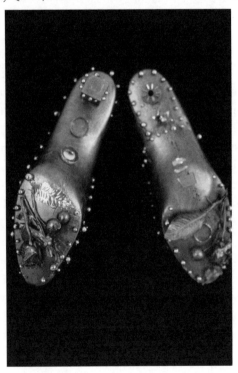

Hamoy's *Queen Jezebel* (1993), although not one of her more complicated works, does make an important feminist point (fig. 9; Pl. V). Jezebel, a Phoenician who dominated her husband King Ahab during his reign from 874–53 BCE, broke many laws and encouraged the worship of idols (1 Kings

21). She was so hated that the Israelites refused to bury her. Instead, she was tossed over the city walls and devoured by dogs except for her skull, her feet, and her hands (2 Kgs 9:35–37).

The great Talmudic scholar, Adin Steinsaltz, has called her "perhaps the most perfect representation of the force of evil in the whole of Scripture" (211; see also Patai, *Hebrew Goddess* 42). But Hamoy will have none of that. Legends indicate that she joined both marriage and funeral ceremonies of strangers, that she was quite capable of empathy for those celebrating happy occasions as well as those mourning the deaths of loved ones (Ginzberg IV, 189). In our own day, entertaining newly-weds by dancing at their weddings is still considered to be a good deed (a *mitzvah*). Of all of Jezebel's varied activities, it is this one that Hamoy honored by representing her as a pair of gaudy dancing slippers.

There are several works that will become canonical representations and at least two, by virtue of their creators' ambition, imagination, and—well—audacity will be considered central to that history. These are Ruth Weisberg's *The Scroll* (1986) and Archie Rand's *The Chapter Paintings* (1989).

Weisberg's *The Scroll* is ninety-four feet in length and is meant to be experienced in the round as if it were an open Torah scroll that envelopes the viewer. It is based on the themes of Creation, Revelation and Redemption and encompasses biblical history, Weisberg's personal history, religious events, twentieth-century history, *midrash* and is—above all else—a very nervy thing to have done. Probably nothing like this had ever been attempted before in Jewish American art and some scenes would not have appeared before the advent of the Jewish feminist movement in the 1970s.

Although I will discuss a few images to give some sense of its scope, I will illustrate only one scene. Near the beginning of the creation section is an image of an angel touching a baby in utero. According to midrashic traditions, the souls in the womb have complete knowledge of Torah and do not want to be born because they will forget everything at birth. So an angel has to speed the birth process. Then there is a circumcision scene for boys followed by the *bat mitzvah* of Weisberg's daughter, presided over by a woman rabbi. These are ritual and life cycle scenes. Then we see children, some awaiting their fate in Europe during the Holocaust and others dancing in a circle because they survived the Holocaust and will be leaving soon for Israel. This is contemporary history. Next there is a scene of children being enfolded by a Torah as an older generation watch from afar (fig. 10; Pl. V). This is partly inspired by modern religious ritual Weisberg has staged of a community holding open and feeling enveloped by the Torah, a scene reinforced by the structure of the entire piece.

Finally, Weisberg's work addresses the theme of Redemption. There is a col-
lection of concentration camp clothing juxtaposed with a distant vision of the
Jerusalem that the camp inmates will never see. Weisberg has also included
Israelite tents in the desert that suggest the exodus from Egypt that also alludes
to a moment in Jewish diasporic history. The juxtaposition of these two images
evokes two different, but in this context equally heartbreaking, passages from
well-known sources. First, the last lines of the Haggadah recited at the end of
the Passover meal, "Next year in Jerusalem! Next year, may all be free!" might
have been in the thoughts of many camp inmates, but such a happy fate would
not come to pass for them. And, second, because it is common to recite certain
psalms in moments of crisis, many in the camps might have had in mind, espe-
cially in their misery, the lines of Psalm 137 that are said before *Tisha b'Av*, the
day set aside to commemorate the destruction of the Temple: "By the rivers of
Babylon, there we sat, sat and wept, as we thought of Zion. . . . If I forget you,
O Jerusalem, let my right hand wither; let my tongue stick to my palate; if I
cease to think of you, if I do not keep Jerusalem in memory even at my happiest
hour" (Ps 137:1, 5–6). Here, Weisberg has intertwined past and present history
with biblical allusions.

*Figure 10. Ruth Weisberg.* The Scroll (Detail). *1986. Courtesy of the Artist.*

In some sections, *The Scroll* is obviously antithetical to orthodox and patriarchal beliefs and modes of thought. Where women were stereotypically portrayed, say, lighting the Sabbath candles, Weisberg has placed them in rituals once assigned only to men. Like the other artists considered here, she has given emphasis to autobiography and modern religious practices while also acknowledging traditional and "official" texts. Her sense of self-definition therefore is primary in choosing images to portray. Fulfillment, then, lies less in adhering to unquestioning religious belief than in filtering that belief through her own values. Think about it! Creating *The* Scroll was an immense challenge—taking on thousands of years of Jewish history and memory and then joining them in a narrative sequence with certain personal life experiences and celebrations, past and present events, a cycle of birth, life, and death, historical triumph and tragedy, and legend and fact. Like the sacred document that gives this work its name, there is nothing quite like it.

There is at least one citation that should be pondered in thinking about the significance of *The Scroll* as a statement about both contemporary Jewish art and contemporary Jewish thought. Social observer Hilary Putnam has held that Judaism can be spiritually enriching when it substitutes reinterpretation for "slavish adherence . . . for all genuine appropriation of tradition involves continued reinterpretation, and tradition that is not constantly reappropriated and reinterpreted becomes fossilized" (115). *The Scroll*, then, is one of the most important visual statements both in the entire history of Jewish-American art and as a statement of contemporary Jewish thought.

Much the same can be said for Rand's *The Chapter Paintings*, which consist of fifty-four paintings for each of the Torah portions or *parashot* read over the period of a single year. Rand, drawing upon his considerable knowledge of Judaism, took an entirely personal approach to the central Jewish text. As with Weisberg's *The Scroll*, nothing like this had previously been attempted. In the section devoted to the death of Sarah, Rand painted the entrance to the cave in which she is buried, depicting it basically as an unobtrusive opening in the side of a hill without an exalted entrance or flanking trees that might allow the viewer to recognize the importance of the person who is, after all, the mother of the Israelite nation. What might Rand have been thinking? Probably, he was commenting on Abraham's questionable relation with his wife, passing her off twice as his sister and taking their son, Isaac, to be sacrificed without telling her (Gen 12:13; 20:2; and 22:2–3). And, according to various midrashic accounts, after Sarah's death, Abraham went back to Hagar and together they had six more children (Ginzberg I, 274, 292).

## III

There are several other artists in addition to those mentioned here who should be included in any comprehensive history of current Jewish American art. In addition to the few, brief overview comments I have made at the beginning of this essay, there are at least three different ways to think about all of these artists. First, at the individual level, there is no single explanation to account for the turn to Jewish subject matter. Some artists come from religious backgrounds, some do not. Some always felt a Jewish connection; others sought it out as adults. Some turn to Jewish themes occasionally, others constantly.

Second, world events might also have prompted artists to turn to Jewish themes. For example, Israel's successes in the Six Day War in 1967 and the Yom Kippur War in 1973 gave Jewish Americans a new sense of pride in their religion and culture. They provided artists with the psychological strength finally to feel comfortable as Jews in America. The civil rights movements of the 1960s, although primarily associated with African-Americans, also inspired Jews to assert themselves, to come out, as it were, as Jews within mainstream culture. Beginning in the 1970s, the Jewish feminist movement encouraged women artists to explore their religious heritage, to question traditional patriarchic versions of biblical history, and to re-study and re-evaluate the ancient sacred texts. Another vital factor might have been negative responses to the strong assimilative tendencies after World War II and to the often demeaning ways assimilated Jews were portrayed in American popular culture by figures such as Philip Roth and Woody Allen (Rubin ch. 4). Finally, the rise of the multi-faceted Jewish Renewal Movement in the 1980s, with its concerns for spiritual regeneration and renewed Jewish identity, had a major impact.

Third, and less tangible, there are issues relating to the artists' relationships to Judaism in general. Their connections to the ancient texts are not the same as in past generations. Whatever artists might know of the religion and its history, I seriously doubt that any today would state as Ben Shahn did in 1963:

> At that time [as a youth in Lithuania], I went to school for nine hours a day. And all nine hours were devoted to learning the true history of things, which was the Bible. Time was to me, then, in some curious way, Timeless. All events of the Bible were, relatively, part of the present. Abraham, Isaac, and Jacob were "our" parents—certainly my mother's and my father's, my grandmother's and my grandfather's, but mine as well (5).

I also doubt that contemporary artists feel as if they directly descend in a continuous line from these biblical figures, but obviously they do seek some legitimate sense of continuity with the past. Reattaching one's self to that line in a decentralized and autonomous American Judaism cannot be done by imitating the ways past artists created scenes with Jewish content. As Arnold Eisen has observed, one's Jewish identification is now quite personal. "It is primarily in private space and time that American Jews define the selves they are and want to be," and that each person decides which rituals and practices to observe.[13] Artists today who find Judaism central to their art find their own point of entrance and go on from there—again, whether it is psychological, feminist, existential, or whatever, and whether it involves biblical individuals or something general or more specific in the religion, there is no overall game plan, let alone a mutually understood and unstated tradition to be taken for granted. Identification is personal and quite diffuse.

At a fundamental level, these artists know that it is not possible to reverse the processes of assimilation completely; nonetheless—perhaps for this very reason—they desire to understand better the sources of their religious beliefs and culture and how to fit these into their contemporary lives. They want to reclaim some lost memories but on their own terms and within traditions of their own invention and adoption.[14] It is as if, while looking to the future, they simultaneously feel the need to find and make a connection to the very distant past. Paradoxically, but very Jewishly, they acknowledge change but seek an unchanging and stable anchor.

Several artists have indicated to me their concerns about the attrition if not outright loss of their culture through assimilation and intermarriage. As a result, they have become part of a broad movement to build a recognizably modern Jewish-American culture distinct, but not entirely separate, from the majority culture and in no way beholden to the now second- and third-hand memories of their eastern-European ancestors. As instances of the desire to establish a modern Jewish culture commensurate with their decentralized Jewish American experiences, they might reconnect through an interest in klezmer music and trips to destroyed European ghettos to search out family documents. They belong to Jewish Community Centers (JCCs); they attend Jewish Studies programs in colleges and universities, and study the Yiddish language.

Most importantly from the perspective of the history of Jewish art in America, artists are forging their own versions of Jewish culture in America based on their own contemporary experiences. In the ways they find and interpret their subject matter, they reveal not a superficial Jewishness but rather a

commitment to and a profound respect for Judaism and what it means to them as artists and as individuals. As a result of their efforts and of what they have so far accomplished, I really do believe—and we need to acknowledge it—we are living in the golden age of Jewish-American art.

## Notes

*. I would like to thank the Memorial Foundation for Jewish Culture, which supported my work in preparation for the publication of this article.

1. I make this assertion based on four books and numerous articles I have written on Jewish American art and two anthologies on modern Jewish art I have co-edited in the past decade and a half. See, for example, *Jewish Art in America*; "The Scroll in Context"; and my articles on Jill Nathanson, Richard McBee, and Archie Rand listed in the notes below.

2. Much of the material that follows is based on roughly twenty years of written correspondence, interviews, and conversations with dozens of artists all over the country. I want to thank all of the artists for their patience in answering my questions and then my further questions based on their answers.

3. For further information on Rand, see Baigell, *American Artists* 201–16; and Baigell, "Archie Rand" 57–79.

4. For an illustration see, Baigell, *American Artists* 121. This can be found on the web, for example at: http://books.google.com/books?id=rw1nkKfW_3sC&pg=PA133&lpg=PA133&dq=Baskin+Moses+woodcut&source=bl&ots=W6ToG4xuqp&sig=ufjKloXuFwdpwqsLxTaspW64dEg&hl=en&sa=X&ei=LZH8T9v_Oqqg2gWzz6XYBg&ved=0CEwQ6AEwAQ#v=onepage&q=Baskin%20Moses%20woodcut&f=false.

5. A horned Moses is a typical Christian depiction hearkening back at least as far as Jerome's translation in the Vulgate in the fifth century CE. It is based on a literal understanding of *qaran* in Exod 34:29 (typically translated "was radiant" but often taken, particularly in Christian circles, to mean "was horned," based upon the assumption that it is a deverbal form of Hebrew *qeren*, "horn." The actual meaning of *qaran*, which only occurs here in the Hebrew Bible, is unclear but possibly could mean that Moses' skin became toughened/disfigured like horn. See, e.g., Propp 620–23.

6. For an illustration, see Baigell, "Archie Rand" 71.

7. See, for example, *Ruth Weisberg Prints* pl. 4; Myers 16; *Heightened Realities* 16–17, 25–26; Ukeles 234–37; and *The Mikvah Project*.

8. For a brief discussion of spiritualism in contemporary Jewish art, see Baigell, "Spiritualism and Mysticism."

9. The "academy," refers to the *tannaim*, teachers and sages who flourished from about 10–210 CE.

10. One might imagine that Mt. Sinai, where the theophany occurred, should be considered a more sacred space, but, of course, the problem with this is that the physical location of Sinai/Horeb is not made clear in the Bible and remains unsettled from ancient times until today.

11. Baigell, "Richard McBee's Akedah Series"; McBee's works, mentioned here, are illustrated in this article. See also *Sarah's Trials: Paintings by Richard McBee*.

12. Jaynes 69ff., 94, 295, 304. Snell wrote similarly about the development of consciousness in Greek thought.
13. Eisen 127, 128. For other statements on the matter of accessing tradition by personal choice, see Cohen 26, 81, 89.
14. This is really the subject for another essay, but see Hobsbawm and Ranger; and Yerushalmi.

## Works Cited

Alexander, Philip S., ed. and trans. *Textual Sources for the Study of Judaism*. Manchester: Manchester Univ., 1984.

Baigell, Matthew. "Abstraction and Divine Contemplation in Jill Nathanson's Paintings." *Sh'ma* 39 (December 2008): 14–15.

———. *American Artists, Jewish Images*. Syracuse: Syracuse Univ., 2006.

———. "Archie Rand: American Artist with a Judaic Turn." *Images* 3 (2009): 57–79.

———. *Jewish Art in America: An Introduction*. Lanham, MD: Rowman and Littlefield, 2007.

———. "Richard McBee's Akedah Series: Reimagining and Reconfiguring Jewish Art." *Ars Judaica* 5 (2009): 107–20.

———. "*The Scroll* in Context." *Ruth Weisberg Unfurled*. Los Angeles: Skirball Cultural Center, 2007. 15–25.

———. "Spiritualism and Mysticism in Recent Jewish American Art." *Ars Judaica* (Israel) 2 (2006): 135–50.

Baskin, Leonard. *Moses*. 1960.

Benjamin, Siona. *Finding Home #61: Beloved (Fereshteh)*. 2003.

Berlin, Adele and Marc Zvi Brettler, eds. *The Jewish Study Bible*. New York: Oxford Univ., 2004.

Bois, Yve-Alain. "El Lissitzky: Radical Reversibility." *Art in America* 76 (April 1988): 172–74.

Boner, Alice, Sadāśiva Rath Śarmā and Bettina Bäumer. *Vastusutra Upanishad: The Essence of Form in Sacred Art*. Delhi: Benarsidars, 1982.

Brander, Rabbi Kenneth. "Scribing Our Covenant: A Vision for Orthodoxy." *Sukkot to Go*. New York: Yeshiva Univ. Center for the Jewish Future, 2010. 18–19.

*Carol Hamoy: Voices*. New York: Ceres Gallery, 1992.

Cohen, Debra Nussbaum. "Rebirth of a Generation." *The New York Jewish World Directions* 217 (December 27, 2004).

Cover. *Bridges* 4 (Winter–Spring, 1994).

Eisen, Arnold M. "Rethinking American Judaism." *American Jewish Identity Politics*. Ed. Deborah Dash Moore. Ann Arbor: Univ. of Michigan, 2008.

Ginzberg, Louis. *The Legends of the Jews*. Trans. Henrietta Szold. Philadelphia: JPS, 1913.

Goldman, Bernard. *The Sacred Portal: A Primary Symbol in Ancient Judaic Art*. Detroit: Wayne State Univ., 1966.

Goodman, Susan Tumarkin, ed. *Jewish Themes/Contemporary American Artists II*. New York: The Jewish Museum, 1986.

Hamoy, Carol. *The Invisible Part of the Children of Israel*. Early 1990s.

———. "The Invisible Part of the Children of Israel." Unpublished essay.

———. *Queen Jezebel*. 1993.

Harris, Ben. "Ethnic Identification Seen on the Wane." *The Jewish Week* 3 April 2009: 11.

*Heightened Realities; The Monotypes of Ruth Weisberg*. Seattle: Frye Art Museum, 2001.

Heschel, Abraham Joshua. *The Sabbath: Its Meaning for Modern Man*. New York: Farrar, Straus, Giroux, 2005 (originally pub. 1951).

Hobsbawm, Eric and Terence Ranger, eds. *The Invention of Tradition*. Cambridge: Cambridge Univ., 1983.

Holtzblatt, Ellen. *Hamabul* or *The Deluge*. 2005.

Idel, Moshe. *Kabbalah: New Persepecives*. New Haven: Yale Univ., 1988.

Jaynes, Julian. *The Origin of Consciousness: The Breakdown of the Bicameral Mind*. Boston: Houghton Mifflin., 1976.

Jewish Renewal Movement. 6 October 2012 <http://en.wikipedia.org/wiki/Jewish_Renewal>.

Kahn, Tobi. *Shalom Bat Chairs—Rachel, Rebecca, Sarah, Leah*. 2007.

Kirschbaum, Robert. *The 42-Letter Name*. 2009. *The Devarim Series*.

———. Letter to Matthew Baigell. 21 July 2003.

———. *Temple*. New Delhi: Fulbright, 1997.

Levinson, Julian. *Exiles on Main Street: Jewish American Writers and American Literary Culture*. Bloomington: Indiana Univ., 2008.

Matt, Daniel Chanan, trans. *Zohar: The Book of Enlightenment*. New York: Paulist, 1988.

———. *The Zohar: Pritzker Edition*. Stanford: Stanford Univ., 2009.

Mayamuni and Bruce Degens. *Mayamata: An Indian Treatise on Housing, Architecture, and Iconography*. New Delhi: Sitaram Bhartia Institute of Scientific Research, 1985.

Mazar, Benjamin. *The Mountain of the Lord*. Garden City, NY: Doubleday, 1975.

McBee, Richard. *Sacrifice*. 2003.

McBee, Richard, JCC in Manhattan and Laurie M. Tisch Gallery. *Sarah's Trials: Paintings by Richard McBee*. New York: Jewish Community Center in Manhattan, 2010.

*The Mikvah Project*. Text Leah Lax. Photographs Janice Rubin. Houston: Wall Printing, 2001.

Myers, Julia R. *Completing the Circle: The Art of Ruth Weisberg*. Ypsilanti: Univ. Art Gallery, Eastern Michigan Univ., 2007.

Nathanson, Jill. *Seeing Sinai*. 2004–06.

———. "Seeing Sinai: A Hevruta Study of Exodus 33–34. Paintings: Jill Nathanson, Commentary: Arnold Eisen." Unpublished essay.

Patai, Raphael. *The Hebrew Goddess*. New York: KTAV, 1967.

———. *Man and Temple in Ancient Jewish Myth and Ritual*. London: Nelson and Sons, 1947.

Propp, W. *Exodus 19–40*. New York: Doubleday, 2006.

Putnam, Hilary. "Judaism and Identity." *Jewish Identity*. Ed. David Theo Goldberg and Michael Krausz. Philadelphia: Temple Univ., 1993.

Rand, Archie. *60 Paintings from the Bible*. 1994.

———. *The Chapter Paintings*. 1989.

———. *The Rabbis II.* 1985. Jewish Museum, New York.

Rubin, Barry. *Assimilation and Its Discontents.* New York: Times, 1995.

*Ruth Weisberg Prints: Mid-Life Catalogue Raisonné.* Fresno: Fresno Art Museum, 1990.

Scherman, Rabbi Nosson and Rabbi Meir Zlotowitz, eds. *The Complete Art Scroll Siddur.* New York: Mesorah, 2005.

Scholem, Gershom G. *Major Trends in Jewish Mysticism.* New York: Schocken, 1961. 265–68. First published 1941.

Shafner, Janet. *Adam and Eve: The Sparks.* 1999.

———. *Women of Mystery, Men of Prophecy: Biblical Visions.* New York: Jewish Heritage Project, 2002.

Shahn, Ben. *Love and Joy About Letters.* New York: Grossman, 1963.

Snell, Bruno. *The Discovery of Mind in Greek Philosophy and Literature.* New York: Dover, 1982.

Steinsaltz, Adin. *Biblical Images.* Trans. Yehuda Hanegbi and Yehuddit Keshet. Northvale, VT: Aronson, 1984.

*Talmud Bavli: Tractate Kiddushin.* New York: Mesorah, 1993.

Tigerman, Stanley. *The Architecture of Exile.* New York: Rizzoli, 1988.

Tishby, Isaiah, ed. and David Goldstein, trans. *The Wisdom of the Zohar: An Anthology of Texts.* London: Littman, 1989.

Townsend, John T. *Midrash Tanhuma II: Exodus and Leviticus.* Hoboken: KTAV, 1997.

Ukeles, Mierle Laderman. "Mikvah Dreams—A Performance (1978)." *Four Centuries of Jewish Women's Spirituality: A Sourcebook.* Ed. Ellen M. Umansky and Diane Ashton. Boston: Beacon, 1992. 234–37.

Wander, David. *The Drawings of Jonah.* Late 1990s.

Weisberg, Ruth. *The Scroll.* 1986.

Whitfield, Stephen J. *In Search of American Jewish Culture.* Hanover, NH: Brandeis Univ., 1999.

Yerushalmi, Yosef Hayim. *Zakhor: Jewish History and Jewish Memory.* Seattle: Univ. of Washington, 1982.

# Contemporary Jewish Art:
# An Assessment

## *Richard McBee*

### THE PROBLEM

The idea of "Jewish Art" is such a strange and troubled notion. Long denied even as a possibility, based on an overly simplistic reading of the Torah's abhorrence of idolatry (cf. Exod 20:4–5; Deut 5:8–10),[1] since the eighteenth century, as noted by Kalman Bland, "Jewish aniconism finally emerged as an unmistakably modern idea." His deconstruction of Jewish aniconism sees this notion as initially a non-Jewish invention with anti-Semitic undertones—so much so that, "If not for Kant and Hegel the denial of Jewish art would not have been invented" (8). And, in spite of the fact that this notion flies in the face of the substantial historical record of Jewish visual creativity dating from antiquity to the present,[2] the concept that Jews inherently do not and cannot produce a visual culture was frequently championed by the Jews themselves. Bland lists notable modern Jewish proponents of the aniconic theory, including Bernard Berenson, Harold Rosenberg, Max Dimont, Hannah Arendt and Emmanuel Levinas (Bland 40–44). Cynthia Ozick sums up this cultural prejudice with her declaration: "Where is the Jewish Michelangelo, the Jewish Rembrandt . . . ? He has never come into being. . . . Talented a bit, but nothing great. They never tried their hand at wood or stone or paint. 'Thou shalt have no graven images'—the Second Commandment—prevented them" (278). While patently untrue within contemporary *halachic* understanding, the uneven application by the Rabbis of the Second Commandment through the ages and admittedly circumscribed Jewish visual creativity has certainly served

to hamper Jews' confidence in their abilities to develop a creative visual free-
dom (Mann).[3] That is, at least until the mid-twentieth century.

## DEFINITIONS

First some definitions that can help us clarify what we mean by "Jewish Art."
For purposes of this discussion, Jewish visual art does not include Judaica and
synagogue architecture, because there is no argument about these forms in
terms of their permissibility or their extensive use throughout history.

The most parochial definition codifies Jewish Art as limited to cultural
production utilizing specific Jewish subject matter, drawn from Jewish sacred
and secular texts that explore Jewish social life, history and ritual. Since content
is the defining factor, this can and should also include artwork created by non-
Jews. On the other hand, the more catholic view would include any kind of art
that Jews happen to create that reference the broadest Jewish concepts such as,
peace, spirituality, brotherhood, *tikkun 'olam*, ethnic identity and family. Here
the subjects mirror the individualistic and pluralistic contemporary American
culture. However defined, in all its permutations it is its Jewish content that
denotes the work as Jewish Art. While both formulations are important to a
vital Jewish Art, important distinctions must be made in order to understand
better the consequences of each approach.

## GOLDEN AGE

Jewish Art since the 1970s has been slowly gaining a distinct identity, a dawn-
ing consciousness of a cultural movement greater than the sum of its creators
and creations. This consciousness has gained the most traction in the United
States, even though hints of it are arising in other parts of the world. In par-
ticular, some Israeli artists are touched by this consciousness, although they
are caught in a double cultural bind. For them, Jewishness is of course a given,
since Jewish subjects typically form an integral part of the fabric of their up-
bringing. Nonetheless for many years the Israeli art world has taken its cues
from the New York art world that overtly rejects the notion of "Jewish Art."
Therefore, significant resistance still exists in Israel to the very notion of the

category, Jewish Art. So when historian Matthew Baigell declared in a lecture at the Jewish Museum in New York on March 7, 2011 (now revised in this volume): "We are living in a golden age of Jewish American art," part of the silence that greeted his thesis reflected a redoubling of institutional and international resistance to the appropriateness of "art" being qualified by the descriptor, "Jewish" (unpublished lecture; a summary appeared as "The Arty Semite").

## MUSEUMS

Moreover, most American Jewish museums are remarkably resistant to exhibiting contemporary Jewish Art—that is, art created with a self-consciously explicit Jewish content. With rare exceptions, the artists who are the most committed to Jewish subject matter have been passed over. To be sure, American Jewish museums, large and small, tend to be fully supportive of historical exhibitions of Jewish visual and material culture, and relish exploring a given Jewish individual's involvement in mainstream culture. While many are publicly and even stridently committed to diversity, tolerance, interfaith dialogue and community involvement, they seem to have a blind spot regarding promoting and exhibiting contemporary art with explicit Jewish content. It may be institutionally understandable that they have major concerns about limited and shrinking budgets—along with deep fears of seeming "too Jewish" within an assumed dominant, assimilationist culture; nonetheless, their stance is deeply problematic. Still, turning such a blind eye to overtly Jewish-themed art is hardly conducive to its long term well-being. In fact, one might observe that such myopia evinces a pathological adherence to an anachronistic paradigm of the role that Jews should play (and not play) in American culture. For at least twenty-five years the mantra of social diversity was normative in encouraging explicit cultural expressions of black, ethnic, feminist and gay culture. Somehow only explicit Judaism is still anathema.

Nonetheless, Baigell finds this rising tide of Jewish-themed visual art to be profoundly broad-based, wonderfully chaotic, and—above all—exhilarating. The artists who are leading the way take their themes from a wide range of sources. The Bible, Talmud, Kabbalah, midrash, ritual and all aspects of American Jewish life are all fair game for contemporary Jewish artists. The only unifying feature that underpins this artistic eclecticism is the desire to depict an identifiably Jewish content.

## BAGGAGE

Significantly, Baigell identifies the sociological foundations for this phenom-
enon. To broadly paraphrase his historical analysis, the generation of Jewish
artists from the first third of the twentieth century tended to move away from
their Jewish heritage and roots. For the vast majority of Jewish artists of that
time, many who were European born, the job at hand was to integrate into
American culture, to be modern and successful and, above all, to fit in with
the overwhelmingly non-Jewish cultural environment. For artists coming of
age in the 1970s and later though, none of that seemed necessary. As second
or third generation Americans who happened to be Jewish, the entire cultural
spectrum, including Jewish thought and subjects, was available with little or no
negative connotations. "The Six Day War in 1967 and the Yom Kippur War in
1973 gave Jewish Americans a new sense of pride in their religion and culture,"
taking their place alongside other minority groups such as blacks, Latinos,
gays and women in the march towards mainstream recognition (26 in ms.). In
an age profoundly defined by identity politics, Jewishness became a publicly
accepted option. Just as walking down the street with a yarmulke no longer
prompted scorn or worse, so too Jewish subject matter could be equally con-
sidered as legitimate for making art. To simplify Baigell's analysis, the crucial
issue is baggage. Baigell's Jews at the end of the twentieth century have little or
no such cultural impediments to hamper their exploration of Jewish themes.

## THE EXCEPTION—VISUAL ART

In the broader view, cutting-edge Jewish culture has been flourishing here ever
since the 1960s, with major development of Jewish themes in literature, music
and performance. Until recently, though, the visual arts have lagged behind.
The reasons are complex. In all other cultural expressions the Jewish presence
had been strong from the heyday of early Modernism, seemingly a natural out-
growth of Jewish assimilation into western secular culture. And while Jews'
participation in American culture was characteristic of their own assimila-
tion, nonetheless they remained deeply Jewish because literature, music and
performance had a long history in traditional Jewish culture as well. In a way
not much had changed for these artists. Therefore once they were no longer
marginalized for a generation or two, they could more easily examine Jewish
subjects explicitly. However, this was not so for the majority of visual artists.

While Jews have always been well represented among twentieth-century visual arts, the shift into explicit Jewish subject matter met with more resistance than in other mediums. As these artists learned their trade as visual artists, they were unaware of any Jewish visual tradition to inform their Jewish conscious-ness. Neither colleges nor art schools ever taught about the extensive history of Jewish art. (With rare exceptions that is still the case today.) The ghosts of a perceived aniconic Jewish history combined with the modernist dismissal of traditional religion and culture as a legitimate subject matter therefore had the impact of shackling Jewish visual artists disproportionately. And while there were notable exceptions, they were almost always ignored because even if the artists managed to break through the conceptual wall, there was practically no audience prepared to appreciate their efforts. But things were about to change.

## MODERNISM / POSTMODERNISM

In the early 1970s the orthodoxies of High Modernism, Abstract Expressionism, celebrating the purity of form and execution, and even the extremes of Minimalism slowly gave way to increasing considerations of non-visual con-tent, first seen in Pop Art's ironic messages. The reintroduction of figurative painting and the advent of photography as a fully recognized artistic medium along with the integration of narration broadened the cultural possibilities for the visual artist. In the following twenty-five years there was a collapse of cul-tural hegemonies that gave way to the relative chaos of Postmodernism. These years celebrated a return to texts, conceptual issues, idiosyncratic techniques and multiplicities of meanings in one work. Postmodernism, according to H. H. Arnason's *History of Modern Art,* "encouraged overtly polemical practices and an ironic distance from conventions of the past." Additionally it was "facili-tated by the tools of Poststructualism and deconstruction . . ." (685). In a very significant manner this multiplicity of means in visual creation along with a complex and arm's length attitude to tradition seemed to echo the complexity of Jewish ideas that were publicly airing within organized American Judaism at the same time.

## JUDAISM

Organized Judaism experienced both a maturation and fracturing in the second half of the twentieth century. While the Reform and Conservative movements grew dramatically at mid-century and traditional Orthodoxy seemed doomed both from the devastations of the Holocaust and the suburban flight of many nominally-Orthodox Jews into more liberal movements and secularism, the unexpected rise of Modern Orthodoxy, the *Baal Teshuvah* movement and the exponential growth of the Ultra-Orthodox have vastly complicated the demographics and content of organized Judaism. The liberal reflections of Judaism are increasingly faced with internal challenges especially linked to intermarriage and plummeting literacy with regard to Jewish religion and culture. In cultural terms, the shifting sands have resulted in increased cross-pollination between Reform, Conservative, Reconstructionism and Jewish Renewal movements. The ongoing expansion of the role of women in Jewish thought and practice as well as a cautious openness to gay, lesbian, bisexual and transgendered individuals has changed the face of all aspects of American Judaism, including its various expressions of orthodoxy. It is no longer simply made up of discrete movements, but rather the options within contemporary Judaism are arrayed in a hodge-podge of frequently overlapping ideas and practices. Additionally, for those who are not literate in Hebrew but who are nonetheless interested in exploring Jewish texts, the proliferation of English translations of many traditional texts has dramatically facilitated accessing the vast body of Jewish lore and tradition, much of which until recently was the sole providence of the learned Orthodox.

Even more startling is the recent profusion of learning programs designed for visual artists called the Artist's Beit Midrash. First conceived and inaugurated by artist Tobi Kahn at the Skirball Center at Temple Emanu-El in New York, there are now at least eight in the United States and one operating in Tel Aviv. This is perhaps the first time in modern Jewish life that artists, mostly liberal and secular, are being exposed to classical Jewish texts for the purpose of creating visual art. All of this bodes well for artists who wish to explore the many aspects of Jewish thought and ideas in light of contemporary society. And increasingly many are doing so.

## JEWISH ART GROUPS

Within the last ten years we have seen the formation of two organizations of artists dedicated to Jewish visual art. The Jewish Artists Initiative, based in Los Angeles, was founded in 2004 by Ruth Weisberg and currently has close to seventy members. In New York the Jewish Art Salon, created in 2008 by Yona Verwer, is much more loosely organized and has 376 artists and over 500 individuals associated with it. The organizations, while very different in scope and focus, share a fundamental belief that Jewish art is a growing movement that needs a forum and organizational support to thrive. Both organizations, along with a handful of other smaller groups have utilized Internet websites and email to create something essentially unheard of before: a National Community of Jewish Artists. The existence of the web as well as almost universal email and social networking sites has greatly facilitated this profusion of artist groups. The very fact of their existence indicates a groundswell of interest and enthusiasm for the idea of Jewish Art. This in turn promotes a proliferation of interconnectivity via the web leading to increased cultural crossovers and hybridization, not to mention the growing sense of an actual movement of Jewish Art. When artists hear that a contemporary historian feels they are collectivity creating a "Golden Age," it is much more than a temporary ego boost. Rather, such an appreciation begins to validate and strengthen their commitment to continuing to create artwork with serious Jewish content.

## GOLDEN AGE—ALMOST

The confluence of Postmodernism, theological diversity and unprecedented social networking has led to a rare moment in Jewish cultural history: increased choice, clarity and freedom in Jewish visual creativity. Hence Baigell's "Golden Age."

Just as any fledgling movement needs a history, so too does it need a vision of what will sustain its continued growth. A critical apparatus is essential for the creation of a nurturing environment of creativity. While I share Baigell's enthusiasm for the profusion of recent serious Jewish art and the enormous range of subjects explored, I simultaneously detect a disheartening hesitancy to tackle a whole host of difficult but enormously fruitful Jewish subjects.

My concern is that far too many contemporary Jewish artists seem content with superficial versions of Jewish ideas combined with an uncritical

appropriation of contemporary art styles. And while, in and of itself, this is not crippling to a cultural movement and may even at times produce a healthy diversity, in order for Jewish Art to become a truly world-class cultural expression, it must confront the depth and seriousness that are inherent in the classical Jewish texts and sources.

To be fair, many contemporary Jewish artists are not even aware of what they are missing. The aforementioned inadequacy of Jewish education, both in terms of Judaism's texts and Jewish Art History is appalling. Both can be remedied but only with considerable individual effort combined with what I consider to be an essential critical apparatus. It is appropriate to encourage Jewish artists to interrogate the very heart and soul of the *Tanakh*[4] into their work boldly and without compunction.

## PARADIGMS

For visual artists there is possibly nothing as rich as the parallel textual traditions of the *Tanakh* and the various midrashic and talmudic texts. The extremely terse nature of the biblical narratives cries out for the kind of textual deconstruction that the rabbis, who wrote the midrashic literature, pursued.[5] In the course of explaining, elaborating or exploding the thorny theological, moral or practical issues the biblical texts present at practically every turn, the ancient rabbinic minds have provided a plethora of diverse strategies for contemporizing these stories. They always have a textual opening or a long-standing tradition of something gone awry which allows them to provide for a creative explanation. Understanding two contradictory thoughts at the same time is central to their methodology since the Torah, according to midrashic tradition, is understood to be able to accommodate "70 different facets," i.e., valid interpretations (Slotki 534). The seeming violence the rabbis do to the original is no less than a ruthless determination to possess the ancient text for themselves as an inheritance that carries enormous responsibility. Rabbinic interpretations, as evocative and disturbing as they may be, are almost never simply personal. While for some Jewish artists there is a lingering hesitancy about actually depicting the patriarchs, matriarchs, holy prophets and kings, this misplaced piety must be resisted.

*Sarah's Nightmare* (2010; fig.1; Pl. VI) by Eden Morris has internalized Sarah's horrified reaction upon hearing of the near slaughter of her son Isaac

in the Akedah.[6] In the face of the biblical silence and the proximity to Sarah's death in the text (Genesis 23), Rashi comments (Petroff, Genesis, 243; see also Friedlander 233–234):

> Genesis: 23:2; *And Abraham came*: From Beersheba; *To eulogize Sarah and to bewail her*: Sarah's death is juxtaposed with the Binding of Isaac because through hearing the news of the Binding, that her son was readied for slaughter and was nearly slaughtered, her soul flew from her and she died.

*Figure 1. Eden Morris.* Sarah's Nightmare. *2010. Oil on canvas, 30 x 30. Courtesy of the Artist.*

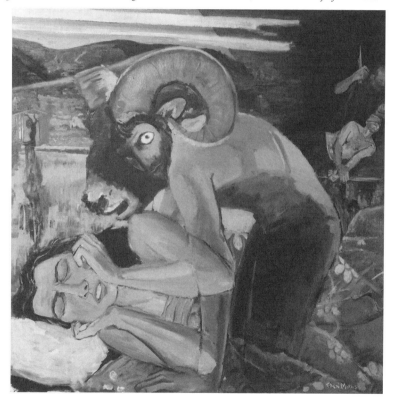

In this radical painting about unintended consequences, the biblical narrative itself is barely seen in the background while the artist's unique take on the midrash is prioritized in the foreground. As Isaac becomes simultaneously the sacrificial ram and Sarah's haunted son, the artist has appropriated both biblical and midrashic texts to place the horror she perceives at the center of the narrative.

Another fruitful approach to classical Jewish texts is to refract them through a post-feminist lens. Precisely because of the undeniably dominant patriarchal nature of so many biblical narratives—all of which tend to attract extensive criticism in Jewish feminist literature—a fresh appraisal of the pivotal role of women and sexuality in nearly all these narratives continues to be compelling and relevant to visual artists of both sexes.

In the Genesis narrative of the three angels who come to visit Abraham (Gen 18:1-15), Sarah plays a passive and meek role. Standing in the shadows of the doorway, she laughs incredulously at the news of her impending miraculous pregnancy at the age of ninety and then clumsily lies to God about the incident. Janet Shafner's *Sarah* (1998; fig. 2; Pl. VI) totally reassesses the matriarch's role. Now sitting in the foreground, patiently waiting, her husband Abraham is nowhere to be seen and the three angels/strangers are likewise waiting, presumably for lunch (cf. 18:6–8). Rising up behind them is a bright but curious landscape dominated by two enormous breast-like mountains. The rivulets that spill down the mountainsides are at first puzzling until one recalls a curious midrash that speaks of a miraculous validation of Sarah in her generative role. The Talmud (*Baba Metzia* 87a) reports:

> How many children then did Sarah suckle? — R. Levi said: "On the day that Abraham weaned his son Isaac, he made a great banquet, and all the peoples of the world derided him, saying, 'Have you seen that old man and woman, who brought a foundling from the street, and now claim him as their son! And what is more, they make a great banquet to establish their claim!' What did our father Abraham do? —He went and invited all the great men of the age, and our mother Sarah invited their wives. Each one brought her child with her, but not the wet nurse, and a miracle happened unto our mother Sarah, her breasts opened like two fountains, and she suckled them all."

Shafner's painting recasts the biblical Sarah's passive role by portraying her as a source of enormous sustenance and blessing by alluding to the extra-biblical legend envisioned by the rabbis.

Such a lens that bends gender tensions and conflicts in the biblical narrative can become a powerful tool for visual creation. And yet all too many artists, curiously including many women, seem to be oblivious to the dynamic and crucial role of women in biblical narratives.

*Figure 2. Janet Shafner. Sarah. 1998. Oil on canvas, 58 x 50. Courtesy the Estate of Janet Shafner.*

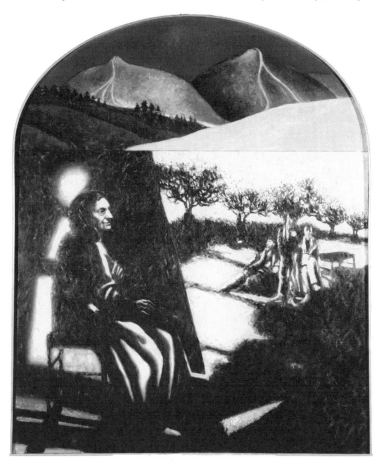

Finally, the biblical strategies of juxtaposition, repetition, serial narratives, and textual contrasts are all underutilized paradigms that could be used to uncover hosts of alternative meanings lurking in these texts. Archie Rand's career is dominated by serial narratives that utilize multiple images, comprising one work of art thoroughly echoing the sequential nature of many Jewish texts. *The Chapter Paintings* (1989) explore fifty-three discreet sections of the Torah; *The Nineteen Diaspora Paintings* (2002) spell out the individual petitions and praises of the *Amidah*, the central Jewish prayer, interpreted through biblical texts envisioned as illustrated pulp fiction; *The Seven Days of Creation* (2004) speak for themselves in a semi-abstract play of free association as well as *The 613* (2008; fig. 3; Pl. VII), perhaps his most ambitious work, measuring in at 1600 square feet and giving each and every commandment in the Torah

its own canvas for Rand to personalize. While many of his works puzzle the viewer with a bewildering complexity of images; nonetheless, his work feels overwhelmingly Jewish because it echoes many primary biblical strategies.

*Figure 3. Archie Rand. The 613. 2008. Oil on 613 canvases, 22' x 100'. Courtesy of the Artist.*

Another artist, who utilizes juxtaposition and textual contrasts, is Robert Kirschbaum, especially in his recent small paintings series, *The Akedah Series* (2008–09). Kirschbaum narrates the Akedah story in ten abstract images that employ three registers to represent heaven, the world of action and the earth below. In a field of frantic gestures, squares arise to form a symbolic altar until there appears to be a violent clash of abstract forces. As the confrontation subsides other square and rectangular forms coalesce into the final image of a doorway that appears to enter a sanctuary. Since this "scene" is in some sense the climax of the Akedah, it would seem that Kirschbaum has taken us to a portal of the Divine. And what triggered this portal to appear is found back in the fifth image, *Akedah 45* (fig. 4; Pl. VII). In this image all of the agitated marks have assembled, each register defined by its own calligraphy, and floating over them all is the immediately recognizable pattern of the Zoharic chart of the ten *Sefirot*, each represented by a nine square grid cube, reflecting ten perfect self-contained universes. In Kirschbaum's depiction it is the fulcrum of the Akedah narrative; the Divine meeting with Abraham and Isaac at the moment of the aborted sacrifice. Blind faith and unquestioning obedience are

rewarded by the revelation of the Divine Presence. Kirschbaum has imposed a Kabalistic synthesis on one of the most disturbing narratives in the Torah and has, as a result, found a remarkable Divine Portal beckoning us.

*Figure 4. Robert Kirschbaum. The Akedah Series: Akedah 45. 2008–09. Mixed media on paper 9 x 8. Courtesy of the Artist.*

These examples of possible "paradigms" that arise out of classic Jewish texts as they collide with some aspects of Postmodernist sensibility are, of course, not exclusive prescriptions for Jewish artists. I offer them only to demonstrate what is possible if our Golden Age artists would consider the many options that the rich traditions of Jewish biblical and rabbinic texts make available to them.

**PROSPECTS**

It should be obvious that, the current revival of Jewish Art can only bloom into a true Golden Age, if it has broad public support, especially from the Jewish community in America. Just as there is now a sustained readership for Jewish oriented literature and ideas (and even occasionally some visual art) in such venues as the *Jewish Review of Books, Tablet, Jewcy, The Forward,* so likewise must we develop the potentiality of a literate visual Jewish culture and audience. Critics and journalists must be encouraged to analyze, thoughtfully comment on and explain these artist's works to a Jewish audience so that both the Judaic and aesthetic elements are treated with equal respect. The public must listen and become engaged. The Jewish museums must overcome their reluctance and open their doors. In order to thrive, the Golden Age must be recognized.

We have made a good start. From out of the wilderness of our own doubts, we have found our way through a troubled past and, thanks to America's loving embrace, we have emerged into a new artistic landscape full of promise. More artists, self-consciously drawing upon Jewish Tradition as a spring board for inspiration, have produced more explicitly Jewish Art. If we can muster the courage to stand apart as proud Jews in contemporary America, while fully embracing 3000 years of our history and close to 2000 years of visual creativity, contemporary Jewish Art has more than a fair chance to find its rightful day in the sun.

## Notes

1. The long and tortuous controversy over Jews creating visual art is perhaps best summed up by Cecil Roth: "In all Jewish history, attitudes and interpretations varied from land to land and from generation to generation. Sometimes the application of the prohibition was absolute . . . even in relatively 'liberal' Jewish circles. . . . Sometimes men went to the other extreme, and great latitude was shown, human figures being incorporated freely even in objects associated with Divine worship" (11).

2. See Sed-Rajna. This excellent survey is simply an introduction to the extensive literature on Jewish art that dates from the third century CE Dura Europos synagogue murals, the many dozens of illuminated manuscripts in fourteenth and fifteenth century Spain and central Europe, the extensive illustrated Haggadot and Jewish books, seventeenth and eighteenth century illuminated Jewish manuscripts, nineteenth century Jewish genre painters and extensive artwork from the Bezalel School in pre-state Palestine and twentieth century modernist masters.

3. The diversity of rabbinic opinion on the permissibility of Jewish image-making is breathtaking. What becomes clear is that in many cases over the millennia visual art was permitted by the rabbis and that, as the threat of idolatry faded, the issue became more academic. My own inquiries, addressed to a number of orthodox rabbinic authorities have yielded the opinion that, other than three-dimensional highly finished and realistic statues, almost all artworks created as artworks are permissible.

4. The term *Tanakh* is an acronym of *Torah-Nevi'im-Ketuvim*, that is, the Torah, the Prophets and the Writings, constituting the three fold division of the Hebrew Bible.

5. I will use the terms midrash, Talmud, and the rabbis interchangeably for simplicity in this essay in describing the extensive Jewish oral tradition of commentary and interpretation.

6. Hebrew for "the Binding," the traditional title given to the story in Gen 22:1–19.

## Works Cited

Arnason, H. H. *History of Modern Art.* 5th ed. Upper Saddle River: Prentice Hall, 2004.

Baigell, Matthew. "The Arty Semite." Summary of unpublished lecture. *The Jewish Daily Forward* Blog 4 March 2011; 1 Oct 2012 < http://blogs.forward.com/the-arty-semite/135884/are-we-living-in-a-golden-age-of-jewish-art/>.

————. "We Are Living in a Golden Age of Jewish American Art and We Really Don't Know It." This volume 1–31.

Bland, Kalman P. *The Artless Jew.* Princeton: Princeton Univ., 2000.

Friedlander, Gerald, trans. *Pirkei de Rabbi Eliezer.* North Stratford: Ayer, 2004.

Kirschbaum, Robert. *The Akedah Series.* 2008–09.

Mann, Vivian B. *Jewish Texts on the Visual Arts.* Cambridge: Cambridge Univ., 2000.

Morris, Eden. *Sarah's Nightmare.* 2010.

Ozick, Cynthia. "Previsions of the Demise of the Dancing Dog." *Art and Ardor.* New York: Knopf, 1983.

Petroff, Rabbi Yisrael Isser, trans. *The Torah with Rashi's Commentary.* Brooklyn: Mesorah, 1995.

Rand, Archie. *The 613.* 2008.

————. *The Chapter Paintings.* 1989.

————. *The Nineteen Diaspora Paintings.* 2002.

————. *The Seven Days of Creation.* 2004.

Roth, Cecil, ed. *Jewish Art.* Greenwich: New York Graphic Society, 1971.

Sed-Rajna, Gabrielle. *Jewish Art.* New York: Abrams, 1997.

Shafner, Janet. *Sarah.* 1998.

Slotki, Judah J., trans. *Midrash Rabbah—Numbers.* New York: Soncino, 1983.

# The Impact and Vitality of New Jewish Art

*Marcie Kaufman*

rowing up as a Reform Jew in Palm Springs, California, I always felt as though I had to give a positive impression of Jews in order to counter any latent anti-Semitism that friends and neighbors might have possessed. This may have stemmed from my being accused of killing Jesus as a kindergartener. It may also have been the result of being one of only five practicing Jews in my high school class of five hundred students. Because the desert is a retirement and resort destination, the majority of Jews living there are senior citizens and snowbirds. Having so few young Jews in my community, I mostly connected to my identity through holiday meals with my family: eating matzo ball soup, pickled herring, and noodle kugel; singing songs; and reciting ritual prayers with my grandparents.

Even though I became a *Bat Mitzvah*, was confirmed, attended Jewish summer camps, and had close Jewish friends, I had very little interest in being involved in Jewish life in college. However, I took a Jewish Studies class through which I began to establish my intellectual engagement with Judaism. And, after much poking and prodding from my mother, I visited USC Hillel for a cooking class. In addition to learning how to make a decent kugel, I was surprised to discover that USC Hillel was an interesting venue for Jewish Art. Within weeks, I was working on exhibitions and soon after became the first student to serve as Director of the Hillel Art Gallery.

Like so many in my generation it was through Jewish Art and Jewish culture that I became engaged as a Jew. Being an artist and an art history major, I was attracted to the creative expressions of various individuals' Jewish experiences. I also found art to be a welcoming and appealing way to include and educate non-Jews. At the opening of the first Jewish student art exhibition

that I curated, several hundred students attended—Jews and non-Jews alike. I was heartened by the turnout and profoundly impressed by the power of art to bring people together, create dialogue, and promote understanding and community.

Art has given me a major entry into and a better understanding of my identity as a Jew. Through an artistic appreciation of Jewish ceremonial objects, I gained a greater understanding of Jewish rituals. Prints, paintings and photographs have also served to illuminate Jewish history for me. As an artist, creating Jewish-themed work has provided me a way to process my feelings and understandings about Jewish values and history, the state of Israel and my personal experience as a young Jewish-American woman.

## ENGAGEMENT AND SUPPORT

My story is but one example of how art and culture engage young Jews. Statistics show that Jews in their twenties and thirties categorize culture (fine art, film, music, food, dance, etc.) as "very important" to their Jewish identities. Elise Bernhardt, President and CEO of the Foundation for Jewish Culture, stated recently, "Art presents a nontraditional way of relating to Jewish values; for young people to whom the traditions are not compelling, art offers a way to cultivate a Jewish identity that, while itself is new, is grounded in deep Jewish values" (Miriam). Likewise, a study completed in 2005 found that "Jewish cultural engagement provides an important link to Jewish life for the intermarried, the geographically remote, the unmarried, and the unaffiliated" (Cohen and Kelman 7).

Jewish organizations have recognized and responded to these data by supporting programs that reach young people through art and culture. In 2006, the Six Points Fellowship was formed "in response to a realization within the Jewish community that culture was becoming a powerful connector in the lives of young Jewish adults and the primary mechanism for creating a common language and furthering identity" ("History and Background"). Six Points supports emerging artists who create work that explores the Jewish experience. Originally a partnership of Avoda Arts, JDub, and the Foundation for Jewish Culture, it received initial major support from the UJA-Federation of New York and is now solely a program of the Foundation for Jewish Culture. The Jewish Federation of Greater Los Angeles, The Jewish Community Foundation

of Los Angeles, and the Righteous Persons Foundation provided the lead funding for the program's expansion into Los Angeles in 2011. Six Points (of which Hadassah Goldvich, Will Deutsch, Alina Bliumis, and Liana Finck, discussed below, are or were Six Points Fellows) is a prominent example of the substantial and meaningful support that major channels of Jewish philanthropy can provide for artists, especially when they bring their resources together in a co-ordinated fashion.

As a testament to their success, art programs are being used by the established Jewish community as a tool for engagement nationwide. In 2007, the Jewish community at the 14th Street Y in New York City launched "LABA: The National Laboratory for New Jewish Culture," a program for visual artists and culture makers with an emphasis on text study. "Rimon: The Minnesota Jewish Arts Council," established in 2004, grew from the Minneapolis Jewish Federation's concerns about Jewish identity, continuity, and community, coupled with many artists' desires to come together, gain attention, and obtain funding.

Jewish visual artists have also established their own groups and programs. Most notably, artists have formed the Jewish Artists Initiative in Southern California, and its offshoot, the Jewish Art Salon in New York City, in order to inspire and stimulate dialogue, generate exhibitions, and promote community through visual art. Websites for these groups and other internet-based Jewish Art forums such as Jewish Art Now, make Jewish artists more accessible and increase their visibility.

Other Jewish organizations that promote entrepreneurship, innovation, leadership, social justice, and education, such as PresenTense, Natan, Jumpstart, Joshua Venture, ROI Community, and the Dorot Foundation, also support new enterprises that utilize Jewish visual arts. PresenTense helps innovators build their ideas into transformational ventures. Independent curator and Jewish Art professional Anne Hromadka participated in the 2011 PresenTense Global Summer Institute and through this highly competitive and instructive program, her Nu ART Projects got its start. Nu ART Projects is a Los Angeles-based initiative that utilizes the visual and performing arts to engage the Jewish community in participatory experiences. Through its successful Seder program, Nu ART is currently supporting individual artists with micro-grants by raising funds at dinner parties, where participants vote on projects that artists present. Jumpstart and Natan, both supporters of Jewish innovation, have provided assistance and funding respectively to Hagaddot.com—a virtual scrapbook that invites people to create their own customizable Passover

Seder Haggadah with artwork, original writing, as well as liberal and tradi-
tional texts. Likewise, Natan and Joshua Venture support G-dcast, a non-profit
dedicated to raising Jewish literacy through lively, animated short films acces-
sible for free on the web. (See the bibliography for web-addresses for these and
other sites mentioned here and elsewhere in this article.)

Reboot, an organization that inspires mostly young unaffiliated Jews to
explore their Jewish identity and community and create projects that make
an impact in both the Jewish and secular worlds, facilitated one of the most
exciting and far-reaching programs in the Jewish visual arts: *Sukkah City: New
York City*—a massive public art installation, showcasing twelve redesigned
sukkahs in Union Square Park. During one weekend in 2010, over 250,000
people visited the temporary holiday structures (or booths) designed by the
finalists in this national architecture competition. Through the appeal of hip,
innovative design, *Sukkah City* engaged the diverse New York community with
an ancient Jewish tradition.

Unfortunately, despite the demonstrated impact of these endeavors,
Jewish institutional support for the arts is now dwindling. Perhaps as a result
of the economic downturn since 2008 and the consequential global crisis in
arts funding, the institutional leaders of the American Jewish community are
pulling away from supporting Jewish Art. UJA-Federation of New York, once
a leader in recognizing the value of art and artists in shaping Jewish identity,
educating and engaging young people, and renewing Jewish culture, is step-
ping back from funding the Six Points Fellowship for Emerging Jewish Artists.
Similarly, the instrumental and thriving exchanges of artists (including visual
artists, choreographers, and musicians), art collectors, and arts professionals to
and from Israel through the visual and performing arts programs of the Jewish
Federation of Greater Los Angeles' Tel Aviv/Los Angeles Partnership were dis-
banded in 2010 after more than a decade of success. Furthermore, the once
thriving JDub had to close its doors after nine years and thirty-five record re-
leases due to a lack in second-stage funding to secure its future. Statistics from
the 2012 study by the Institute for Jewish and Community Research show that
of American Jewish philanthropic dollars donated, less than 1% goes to sup-
porting Jewish Art and related cultural efforts in the US. Although Matthew
Baigell asserts above in this *Annual* that we are now living in the "Golden Age
of American Jewish Art," I would contend that this cultural pinnacle comes
at a fragile moment in time. Indeed support for the artists behind the work is
needed more than ever from Jewish institutions, foundations, and individuals.

## NEW DIRECTIONS IN JEWISH ART

While I would agree with Baigell that we are living in an exceptional time for Jewish Art, I would argue that this is not principally because of work with overt Jewish religious content. Rather, I see the most engaging Jewish Art as coming from younger visual artists in their 20s–40s, exploring their personal Jewish experiences: in other words, work that is inspired by their families, communities, travels or immigrations. When religious texts are referenced explicitly, artists re-imagine rituals, make them their own as well as more relevant to contemporary life and today's vibrant art world. The work takes new form, pushes boundaries and buttons, stimulates questions, and reveals different aspects of Judaism and Jewish life to its viewers.

One result of the identity politics movements of the 1970s and 1980s is that artists now feel freer to explore the once-discouraged subject of their Jewish roots. In this post-post-modern era of art creation, the cynicism and irony prevalent in the 1990s have been replaced by sincere explorations into personal identity. Recently, Anne Hromadka stated in an interview with me, "Jewish artists working today are creating art that is past irreverence. It is culturally relevant while still deconstructing historic motifs" (personal interview). Although some works still depend upon humor and criticality, the resulting works are often seen as earnest, authentic, and insightfully revealing. On occasion art possessing Jewish content is even created by artists who are not Jewish: African-American artist Kehinde Wiley's recent series of paintings *The World Stage: Israel*, exhibited at The Jewish Museum, feature Israeli men with ornate backgrounds inspired by Jewish ceremonial art like *mizrahs* (ornamental wall plaques that designate the eastern orientation for prayer), Torah curtains, and *ketubot* (marriage contracts).

Immigration over the past forty years from the former Soviet Union and Iran has changed the character of the American Jewish population and thus artists' responses to Judaism. Likewise, the ease of international travel coupled with renewed interests in and nostalgia for Jewish history have given rise to artists discovering remnants of Jewish communities in Eastern Europe, Israel, and even China and making new work from their explorations. Artists' increasingly diverse perspectives on the international Jewish experience enrich the art they produce.

As in all contemporary art, Jewish artists are using new modes of production. Now that graphic technologies are easily accessible and working digitally is not so cost prohibitive, artists are approaching their Jewish subjects with new aesthetic choices; they are working on the computer to manipulate

photographs, generate illustrations and graphics, create videos, make anima-
tions, and engage audiences with interactive work on the web. While artists
continue to create in traditional media such as painting, drawing, printmaking,
photography and sculpture, they are also using new approaches prevalent in
the greater art world to create work with Jewish content—for example, works
that employ found objects and combine various media, site-specific installation
art and zines (small printed publications of original or appropriated texts and
images).

**RITUAL**

Instead of simply depicting scenes from biblical sources, artists today are re-
framing religious rituals in innovative ways. Both the 2009 exhibition at The
Jewish Museum *Reinventing Ritual: Contemporary Art and Design for Jewish
Life*, curated by Daniel Belasco, and the 2011 show *Jewish Ritual: Rethinking,
Renewed* at Hebrew Union College, Los Angeles, organized by Georgia
Freedman-Harvey, highlighted artists' inclinations to reimagine biblical text
and Jewish customs. The artists in these exhibitions, some of whom are de-
scribed here, take action and/or invite viewers to do so; ritual is interpreted less
as something one passively follows and more as a practice that one marks, cuts,
eats, exposes and most of all, questions.

Los Angeles-based artist Eileen Levinson's *Commandment Scorecard*
turns the 613 commandments that are found in the Torah and which serve as
the traditional basis for a "proper" Jewish life into an interactive design piece.
Viewers are invited to use a bingo-style stamp to mark the commandments
they have upheld. Each four-foot poster asks viewers to examine their own
Jewish lives and grade themselves against the traditional biblical standard. This
process gives participating viewers a quick, quantitative and amusing, religious
self-evaluation, and often times, new awareness of the scope of all the com-
mandments.

Los Angeles-based Hebrew Union College rabbinical student Ilana
Schachter also engages viewers actively with ritual objects by giving them a
new point of entry into Jewish texts. For her *Exposed Mezuzah* from 2011,
Schachter installed a customized mezuzah at the doorway of the exhibition
space with a QR code—a "Quick Response" barcode—encrypted for smart-
phone users to scan and connect to a specific site on the Internet. By scanning

the code with their cell phones, viewers gain immediate access to a digital image of the enclosed mezuzah-scroll and can also read an English translation of its traditional text from Deut 6:4–9 and 11:13–21. Hence, the small, inscribed "mini-scroll" hidden by the mezuzah's outer shell becomes uncovered; and, as a result, this often-ignored ritual object and the sacred message at its core become activated and are made relevant through this technological twist.

New Haven and New York-based artists Johanna Bresnick and Michael Cloud examined the commandment Ezekiel received (Ezek 3:1–3) from God to eat a scroll of lamentations in their 2006 work *From Mouth to Mouth* (fig. 1; Pl. VIII). In response to the text, Bresnick and Cloud literally cut passages from the book of Leviticus and inserted these printed snippets into gel pill capsules for their installation. The artists said that the "process of transferring the text became a surrogate ritual practice" and the pills became a literal "religious prescription" that invited the "ingestion of knowledge."

*Figure 1: Creative Science Project: Johanna Bresnick and Michael Cloud.* From Mouth to Mouth. *2006. Bible and gel capsules. Dimension vary. Courtesy of the Artist.*

Israel-born, New York-based Hadassa Goldvicht is similarly interested in the idea of ingesting rituals. In the Orthodox Jewish community, boys start school at three years old and their first lesson is the Hebrew alphabet. In order for the children to take in that learning is sweet, the teacher dribbles honey over the letters of the *aleph-bet*, so that each child can lick the sweet shapes.

For *Writing Lesson #1*, a video performance, Goldvitcht takes this ritual on herself. By licking the honeyed Hebrew letters, she consumes the sacred forms and pushes the gender boundaries of this ritual designated for boys—she even sexualizes it.

Finally, for my work, *Hear Here* (fig. 2; Pls. VIII–IX) from 2008, I photographed the *Sh'ma*, widely considered the most important prayer in Judaism, which had been spray-painted as graffiti on a rock formation overlooking the Dead Sea in Israel. Having never seen graffiti in the form of a Hebrew prayer, I was inspired by this confluence of action and place. In turn, I inserted my interpretation of the *Sh'ma* into the crevasses of the image by applying my own detailed hand-drawn graffiti to the surface of the photographic print and highlighted the importance that listening and presence have to language and prayer. *Sh'ma*, the Hebrew word for "hear," is the starting point for the drawing, and it combines topographical maps (including ones of Israel), anatomy and MRI imagery of the ear, and language. The words for "hear" and "here," featured in ten different languages, function as essential building blocks for the body/landscape composite.

*Figure 2a: Marcie Kaufman. Hear Here. 2008. Archival Digital Print with Ink. 16 in. x 20 in. Berman-Bloch Collection. Opposite page: Detail.*

*Figure 2b: Marcie Kaufman. Detail,* Hear Here. *2008. Archival Digital Print with Ink. 16 in. x 20 in. Berman-Bloch Collection.*

## FAMILY

Jewish family life continues to be at the core of Jewish traditions and rituals. Some artists are inspired by their family upbringings to create Jewish art while others turn to their families for source material to comment on Judaism and Jewish culture. While family life is sometimes the starting point, artists today also draw from their personal narratives to create work that reflects the larger contemporary Jewish experience.

Will Deutsch, an Orange County born, Los Angeles-based artist, grew up Orthodox until his mother became a cantor in the Conservative community. His family ranges in their observance of Judaism from ultra-religious to atheistic, yet all members identify themselves as Jews. Deutsch states that in response to his family, he "took it upon [him]self to make paintings that encapsulate the essence of what it is that ties [them] all together" ("About").

Deutsch's work depicts all aspects of Jewish life from familial to stereotypi-
cal, biblical to kitsch. He pays homage to his mother in a recent drawing of a
female cantor, pokes fun at "shiksa" appeal, earnestly portrays young David in
Goliath's shadow, whimsically reinterprets internet love connections provided
by JDate (fig. 3; Pl. X), and lovingly elevates a Hebrew National hotdog ven-
dor because, he boasts, "[Judaism is] the only religion with [its] own brand of
hot dog" ("Kosher Hot Dogs"). In addition to creating his intimate illustrations
that stem from cartooning and Judaica, Deutsch assembles his work in *Notes
from the Tribe*—a website that pairs his artwork with insightful and often times
extremely funny personal essays about the origins of each piece, as well as a se-
ries of zines on specific themes, like the *Bar Mitzvah* and Jewish food. Deutsch's
oeuvre appears to be a celebration of all things Jewish. He finds something
relevant, poignant, or humorous about nearly every aspect of Jewish life.

*Figure 3: Will Deutsch. Jdate. 2010. Ink and Watercolor on Paper. 8.5 in. x 11in. Courtesy of the
Artist.*

Like Deutsch, New Jersey-based artist Hanan Harchol combines writing with illustrations to consider universal questions within a Jewish framework to uplifting, sometimes humorous, and at other times profound ends. Harchol creates video animations that employ family narratives to delve into Jewish ideas, traditions, and psychology, revealing the artist's complicated relationship with Judaism. In Harchol's series of animations entitled *Jewish Food For Thought*, topics such as forgiveness, gratitude, love and fear are discussed, or more aptly argued, between the animated likeness of the artist and his father, an Israeli nuclear physicist originally from Eastern Europe.

Carol Es's Jewish family also inspires her mixed-media work, but in a very different way. She noted, "Growing up in the sweatshops of the Los Angeles apparel industry with my dysfunctional family has become the thread that flows through my work. Dreams, childhood memory, and the materials from the garment manufacturing trade creep into my artwork providing a kind of redemption" (24). She depicts family anecdotes with paint together with thread, fabric, and paper patterns in a child-like style. Often she employs Hebrew letters or words to push their Jewish content. For example, in *Forgiveness on My Sleeve*, Es paints a form of the Hebrew word "*salach*," meaning "to forgive or pardon," on a paper pattern sleeve-shape used for sewing garments. While likely a personal reflection about the artist's parents, this work also speaks to the larger value of forgiveness in Judaism as well as references the *Al Chet* penitential prayer, requesting atonement, that Jews recite on *Yom Kippur* while beating their chests. Es's work is raw, layered with meaning, and sheds new light on the *shmata* business, Yiddish for the "rag" trade.

## IMMIGRATION

The immigrant experience is central to the Jewish-American story. Emigration of Jews from Eastern Europe to the United States from the 1880s–1920s is a major focus of Los Angeles' Skirball Cultural Center's core exhibition, *Visions and Values: Jewish Life from Antiquity to America*. Likewise, at New York's Museum of Jewish Heritage: A Living Memorial to the Holocaust, the immigrant story is updated and made personal in the long-running temporary exhibition, *Voices of Liberty*. From its dramatic location overlooking the water from Battery Park, museum visitors can see the strongest icons of American immigration—the Statue of Liberty and Ellis Island. The exhibition pairs the view with voices of

diverse people, from Holocaust survivors and refugees to celebrities, who share their testimonies about arriving in the United States. Visual artists have also explored immigration in their work. Eminent Jewish contemporary artist Ruth Weisberg created an epic twenty-nine-foot mural painting for the New York Jewish Federation entitled *New Beginnings: 100 Years of Jewish Immigration* depicting the Jewish Diaspora with a combination of historic and personal imagery that spans the experience of departing Eastern Europe, traveling by ship and later by airplane, and arriving in the United States and Israel. Now, younger artists are mining their personal or communal immigrant experiences in new ways and revealing its continued relevance in the American Jewish experience.

The husband and wife team of Alina and Jeff Bliumis were born in Minsk, Belarus and Kishinev, Moldova, respectively; and, during the Third Wave of Russian immigration from the 1970s–1990s, both fled political turmoil and anti-Semitism, seeking a safe haven in the United States. Based in New York City, the artists' immigrant experiences are reflected in the themes that permeate their work, including foreignness, acclimation, migration, refuge and identity. For their *Casual Conversations* project, the Bliumises staged a series of artist-interventions and public discussions in the large Russian Jewish community of Brooklyn's Brighton Beach. By engaging passers-by on the boardwalk, they were able to photograph the eclectic beachgoers holding signs with the words that describe their identities—American, Russian, and/or Jewish. The specific words that individuals included, eliminated, and ordered collectively indicate the struggle immigrants have juggling their new identities while holding on to their cultural roots. The action of publicly proclaiming Jewish heritage also reflects the extreme contrast between the prejudiced Russian societies the immigrants left and the safety of religious freedom Jews enjoy in America.

Los Angeles-based Persian artist Jessica Shokrian's video triptych, *Six Years, Twelve Minutes and Two Seconds*, featured in the nation-wide traveling exhibition, *The Jewish Identity Project: New American Photographs* in 2006, reveals the impact of immigration on the conflicted identity of the artist, a first-generation Persian Jewish-American woman: The three monitors used in this video presentation show the artist's family, focusing on Jewish life-cycle events and rituals, her aunt's trip to a Persian market, and distorted images of the artist, herself. Susan Chevlowe, the exhibition's curator, saw Shokrian's widowed aunt's bus trip to the market as "a metaphor of the displacement and longing experienced by an immigrant living between cultures" (Pfefferman). Recently, Shokrian was asked to revisit these themes for a new installation in connection with *Light & Shadow: The Story of Iran and Jews*, a major traveling

exhibition on view at the Fowler Museum at UCLA, beginning in the fall of 2012. Disconnection, loneliness and loss linger through the videos as well as the artist's yearning to negotiate, understand and accept her own identity.

Instead of drawing from her personal experiences, New York artist Liana Finck uses letters to the editor of the "Bintel Brief" advice column from *The Forward* newspaper to create a graphic novel that reflects the Jewish immigrant community in New York City at the turn of the twentieth century. These letters, originally in Yiddish, sought help from a columnist (a precursor to Ann Landers and Dear Abby, Jewish twins who took this genre into the mainstream media). In Finck's hands, each letter is transformed into a series of comic book-styled drawings that have a unique character, reflecting Finck's interpretation of the personality of the writer. The work sheds light upon the diverse experiences— often times heart-wrenching, occasionally humorous—of Eastern European Jewish immigrants: from the woman who was saved from the Triangle Factory Fire by her devoted husband, who subsequently died while trying to save other women, to the barber who dreams of giving George Washington a shave, to all the family tribulations in between about uprooting lives, missing home, and reconnecting with family members. Finck gives a contemporary voice to those long gone immigrants and helps viewers remember the individual narratives that make up the larger Jewish immigration story.

In addition to examining the Jewish immigrant experience, artists are also inclined to turn their attention onto the lands that Jews left behind, forcibly or intentionally. In an effort to connect with generations past and discover the Jewish history of specific places, artists have traveled to what were once thriving communities to search for remnants of Jewish life and create work that reflects on its loss. Los Angeles-based artist, Adrienne Adar, found traces of Jewish life in Shanghai, China. For her *Jewish Shadows* series, she photographed the doorways, shacks, and alleys of what was once Shanghai's Jewish ghetto; her images reveal the history of the community that took refuge there during World War II but which has nearly disappeared today. Similarly, in my artwork, I photograph remnants and sites of former Jewish life: Boyle Heights, once the heart of the Los Angeles Jewish community that is now predominantly Hispanic; the Lower East Side of Manhattan, the former New York Jewish hub, which is currently part of Chinatown; as well as similar displaced locales in Israel, China, Cuba and Germany. I am interested in personally relating to these places, learning their history through discovering tangible bits of their Semitic roots, and physically connecting to the sites where biblical, communal, and genealogical ancestors lived and thrived, died and often, from which many

of them fled. In addition to reclaiming these historic Jewish places by visiting them, I often reinsert Jewish culture into my photographs by digitally altering the images or painting on the prints.

Another example of an artist using an experience of immigration or transience is Maya Zack's installation *Living Room* (fig. 4; Pl. XI) exhibited in 2011 at The Jewish Museum. In that evocative piece this Israeli artist traveled through the memories of Holocaust survivor Manfred Nomburg to his former home in Berlin. From Nomberg's precise descriptions of the apartment that he fled in 1938 for Palestine, Zack created a computer-generated 3-D model of the forcibly abandoned space, reconstructing it with furniture, ceremonial objects, paintings, tableware, appliances, and its two sources of music, the piano and radio. In addition to faithful depictions of pristine period furnishings suggesting immigrants' idealized memories of home, Zack also alludes to gaps in memory by including holes in the building's structure, revealing plumbing and ghostly images, such as that of the bookcase, referencing Nomberg's inability to recall its exact height. As viewers examine the digital prints and step into the 3-D illusions, they listen to an English translation of the eighty-eight-year-old Tel Aviv man's account of his childhood home. Zack's work gives twenty-first century audiences a glimpse into the private German Jewish home before Kristallnacht, and she literally and figuratively pieces back together what was brutally destroyed during the Holocaust. Zack uses the specific details of one personal story at one precise location during one transformative moment in history to create a work that powerfully and transcendently evolves into a universal statement about loss, memory, and the effects of the Holocaust on the communal Jewish psyche.

*Figure 4: Maya Zack.* Living Room 2 *(2D version). 2009. Digital Prints (3D virtual model anaglyphs/ 2D), sound. 4 ft. high x 10 ft. wide. Courtesy of the Artist.*

The strength of Israeli contemporary art, especially in photography and digital media, has deeply enriched the global Jewish Art dialogue. Artists such as Michal Rovner, Adi Nes and Barry Frydlender have brought Israel and Jewish content into top-tier museums and galleries worldwide, increasing mainstream audiences' access to and appreciation of Jewish Art. Organizations like Artis, the Foundation for Jewish Culture, the Jewish Federation's Tel Aviv/Los Angeles Partnership (cultural programs from 1997–2010), and the Jewish Artists Initiative have stimulated awareness, initiated exchange, and promoted conversations with Israeli artists. USC's new Initiative for Israeli Arts and Culture will certainly become a leader in Los Angeles for engagement with Israel in artistic terms and, in doing so, will push forward the discourse around Jewish Art.

The vibrancy of contemporary Jewish life—from pluralistic religious rituals to diverse families to international Diaspora—is reflected in Jewish Art today made by a new generation of artists. In turn, the art is making a profound impression on the global Jewish community. In order for this vitality in Jewish Art to continue and grow, artists must be supported, encouraged and given constructive criticism. As Aaron Bisman, former President and CEO of JDub, stated, "Great works of Jewish art challenge us and push us to ask questions and delve deep inside. That only happens when you have deep, thoughtful work. I really believe that requires a practice of feedback and self-reflection that I'm often afraid we lack in the Jewish community" (Hromadka, "Innovation and the Arts"). As more and more artists cull their identities for artistic inspiration, the Jewish community must push them forward by carefully considering their work and asking them the difficult questions they would pose to any contemporary artist. Likewise, audiences should expect more than simple depictions of biblical passages. They should insist on new creative interpretations of the Torah, certainly a modern form of visual *midrash*, as well as different impressions of what it means to be Jewish in the twenty-first century. Jewish Art should expand viewers' understandings of the contemporary Jewish experience and speak to audiences outside of the Jewish community. While Jewish Art will always resonate in Jewish spaces, I hope that over the course of this century the work will be increasingly appreciated for its merit, exhibited and collected in more mainstream art museums and galleries, and that it may be incorporated into and enrich the canon of the most significant American contemporary art. In order for Jewish Art to reach new heights and make an even greater worldwide impact, the Jewish community must invest in its artists and art programming, give them the time and resources to grow, and promote the exceptional work that they are certain to produce.

## Works Cited

Bernstein, Fred A. "A Harvest of Temporary Shelters." *The New York Times* 16 Sept 2010. 16 July 2012 <http://www.nytimes.com/2010/09/ 17/arts/design/17sukkah.html>.

Bresnick, Johanna and Michael Cloud. Creative Science Project: *From Mouth to Mouth.* 2006.

*Bresnick & Cloud: From Mouth to Mouth, 2006.* Video. *Reinventing Ritual Gallery.* Prod. MediaCombo, Inc. 2009. The Jewish Museum. 10 June 2012 <http://www.thejewish-museum.org/core/uploaded/media/reinv_ritual/reinv-gallery.html>.

*Carol Es.* 2012. 9 July 2012 <http://esart.com>.

"Casual Conversations." *Alina and Jeff Bliumis.* 24 May–11 July 2012 <http://www.bliu-mis.com/casualconv.htm>.

Cohen, Steven M. and Ari Y. Kelman, *Cultural Events and Jewish Identities: Young Adult Jews in New York.* New York: UJA-Federation of New York, Feb 2005.

*Culture Shuk: A Project of the Foundation for Jewish Culture.* 9 July 2012 <http://cul-tureshuk.com>.

Deutsch, Will. *Jdate.* 2010.

———. "Kosher Hot Dogs, Notes from 10.17.11." *Notes from the Tribe.* 9 July 2012 <http://notesfromthetribe.com/index.php/home/entry /kosher_hot_dogs/>.

———. "About." *Notes from the Tribe.* 9 July 2012 <http://notesfromthetribe.com/in-dex.php/about/>.

*Dorot Foundation.* 27 June 2012 <http://www.dorot.org/>.

Es, Carol. "Carol Es Artist Statement." *A Gathering of Sparks: Jewish Artists Initiative, 2004–2011.* Ed. Marcie Kaufman and Ruth Weisberg. Los Angeles: Jewish Artists Initiative of Southern California, 2011.

Forward Staff. "JDub Records To Close Amid Financial Strain." *The Jewish Daily Forward* 12 July 2011. 21 June 2012 <http://forward.com/articles/139770/jdub-re-cords-to-close-amid-financial-strain/>.

*G-dcast.* 24 June 2012 <http://www.g-dcast.com>.

*Haggadot.com.* 11 July 2012 <http://haggadot.com>.

Harchol, Hanan. *Hanan Harchol.* 2010. 9 July 2012 <http://www.hananharchol.com>.

"History and Background." *Six Points Fellowship.* 12 June 2012 <http://sixpointsfellow-ship.org/about>.

Hromadka, Anne. "Innovation and the Arts: Cultural Change Agents Speak Out." *PresenTense Magazine* Fall 2011: 42. *Issuu.* 7 June 2012 <http://issuu.com/presen-tense/docs/pt15>.

———. Personal interview. 14 June 2012.

Idov, Michael and Dan Ochiva, eds. *Alina and Jeff Bliumis: Receiving the Stranger.* New York: CheckOff Art, 2007.

Isenberg, Barbara. "Funny, you don't look . . ." *The Los Angeles Times* 19 March 2006. 6 July 2012 < http://articles.latimes.com/2006/mar/19/entertainment/ca-identity19>.

*Jewish Artists Initiative.* 2005–12. 23 May 2012 <http://jaisocal.org>.

*Jewish Art Now.* 23 May 2012 < http://www.jewishartnow.com/>.

*Jewish Food For Thought.* 9 July 2012 <http://jewishfoodforthought.com/>.

*The Jewish Identity Project: New American Photography.* Exhibition. *The Jewish Museum.* 12 July 2012 <http://www.thejewishmuseum.org/exhibitions/JewishIdentityProject/gallery>.

The Jewish Museum. "Reinventing Ritual." *Zeek: A Jewish Journal of Thought and Culture* 21 Oct 2009. 10 July 2012 <http://zeek.forward.com/articles/115626/>.

"Joshua Venture Group: Fellows." *Joshua Venture Group.* 24 June 2012 <http://joshuaventuregroup.org/fellows>.

*Jumpstart.* 2008. 11 July 2012 <http://jewishjumpstart.org/>.

Kaufman, Marcie. *Hear Here.* 2008. Berman-Bloch Collection.

Kaufman, Marcie and Ruth Weisberg, eds. *A Gathering of Sparks: Jewish Artists Initiative, 2004–2011.* Los Angeles: Jewish Artists Initiative of Southern California, 2011.

*Kehinde Wiley / The World Stage: Israel.* Exhibition. *The Jewish Museum.* 24 June 2012 <http://www.thejewishmuseum.org/exhibitions/kehinde-wiley>.

"LABA." *14th Street Y.* 23 May 2012 <http://www.14streety.org/index.php?src=directory&view=landing_pages&category=LABA>.

Levinson, Eileen. *Commandment Scorecard. Doikayt Seder Plate.* 27 June 2012 <http://eileenmachine.com/ scorecard.html>.

Ludwig, Erik and Aryeh Weinberg. "Following the Money: A Look at Jewish Foundation Giving." *Institute for Jewish and Community Research.* February 2012. 4 June 2012 <http://www.jewishresearch.org/quad/01-12/following-money.html>.

*Marcie Kaufman.* 2012. 9 July 2012 <http://marciekaufman.com>.

*Maya Zack: Living Room.* Exhibition. *The Jewish Museum.* 6 July 2012 <http://www.thejewishmuseum.org/exhibitions/zack2011>.

Miriam, Yael. "Art For a Change." *PresenTense Magazine* Fall 2011: 44. *Issuu.* 7 June 2012 <http://issuu.com/presentense/docs/pt15>.

"Natan: Grants." *Natan.* 24 June 2012 <http://www.natan.org/html/emergent_jewish_communities.htm>.

*Nu ART Projects.* 26 June 2012 <http://www.nuartprojects.com/>.

"Panelists Speak Up—Speakers' Lab." *Speaker's Lab: Exploring New Perspectives on Jewish Culture and Identity.* 15 May 2012. 25 May 2012 <www.speakerslab.org/category/panelist-statements/>.

Pfefferman, Naomi. "Video Bares Artist's Obsession, Views." *Jewish Journal* 23 March 2006. *JewishJournal.com.* 5 July 2012 <http://www.jewishjournal.com/arts/article/video_bares_artists_obsession_views_20060324/>.

*Reboot.* 9 July 2012 <http://www.rebooters.net>.

*ROI Community.* 16 July 2012 <http://www.roicommunity.org/about>.

Schachter, Ilana. *Exposed Mezuzah.* 22 Nov 2011. 27 June 2012 <http://exposedmezuzah.wordpress.com/>.

"Special Exhibitions." *National Museum of American Jewish History.* 11 July 2012 <http://www.nmajh.org/specialexhibitions/>.

Steinhauer, Jillian. "Kehinde Wiley Paints Israelis in Color." *The Jewish Daily Forward* 23 March 2012: 11, 13.

"Sukkah City." *Sukkah City: NYC 2010.* 9 July 2012 <http://www.sukkahcity.com/>.

Tischler, Linda. "Soundscape of Immigrant Voices Shapes Exhibit at the Museum of Jewish Heritage." *Fast Company.* Mansueto Ventures LLC, 3 Nov 2009. 11 July 2012 <http://www.fastcompany.com/blog/linda-tischler/design-times/they-re-coming-america-new-museum-exhibit-where-immigrant-voices-ar>.

*Voices of Liberty.* Exhibition. *Museum of Jewish Heritage.* C&G Partners LLC, 2009. (Testimonies and speakers' photographs provided by the University of Southern California Shoah Foundation Institute for Visual History and Education and the Museum's collections.) 10 July 2012 <http://www.mjhnyc.org/ khc/voices/about/>.

Wolff, Rachel. "Rooms Furnished With Memories." *The New York Times* 4 Aug 2011. 9 July 2012 <http://www.nytimes.com/2011/08/07/arts/design/jewish-museum-installation-by-maya-zack.html>.

Zack, Maya. *Living Room 2* (2D version). 2009.

PLATE I

*Archie Rand.* The Rabbis II. *1985. Oil on canvas, 58 x 48 in. Courtesy of the Jewish Museum, New York.*

*Janet Shafner.* Adam and Eve—The Sparks. *1999. Oil on canvas, 58 x 50 in. Courtesy of the Artist.*

PLATE II

*Ellen Holtzblatt.* Hamabul: The Earth Became Corrupt Before God. *2005. Woodcut on Japanese Paper, 7 ½ x 14 in. Courtesy of the Artist.*

*David Wander.* The Drawings of Jonah: The Word Came to Jonah. *Early 1990s. Ink and water color on paper, 20 x 41 in. Courtesy of the Artist.*

PLATE III

*Jill Nathanson.* Seeing Sinai: When My Glory Passes I Will Place You . . . *2004. Acrylic on Canvas, 54 x 54 in. Courtesy of the Artist.*

*Robert Kirschbaum.* From the 42-Letter Name *with a complete cube. 2010. Letterpress relief print, 8 x 5 in. Courtesy of the Artist.*

PLATE IV

*Tobi Kahn.* Shalom Bat Chairs—Rachel, Rebecca, Sarah, Leah. *2007. Acrylic on wood, 41 ¾ x 45 ¾ in. each panel. Courtesy of the Artist.*

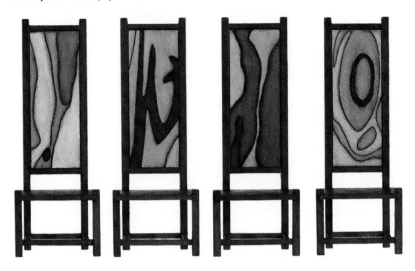

*Richard McBee.* Sacrifice. *2003. Oil on canvas and collage, 20 x 24 in. Courtesy of the Artist.*

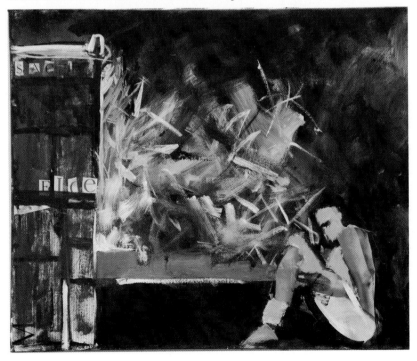

PLATE V

*Carol Hamoy.* Queen Jezebel. *1993. Mixed media, 18 x 7 ½ x 4 ½ in. Courtesy of the Artist.*

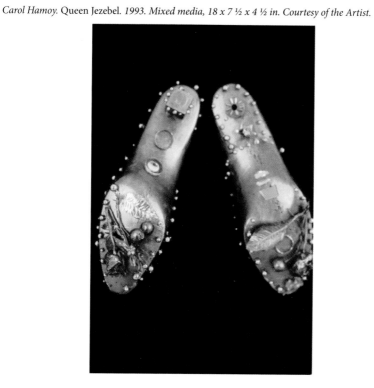

*Ruth Weisberg.* The Scroll (Detail). *1986. Courtesy of the Artist.*

PLATE VI

*Eden Morris.* Sarah's Nightmare. *2010. Oil on canvas, 30 x 30. Courtesy of the Artist.*

*Janet Shafner.* Sarah. *1998. Oil on canvas, 58 x 50. Courtesy the Estate of Janet Shafner.*

PLATE VII

*Archie Rand. The 613. 2008. Oil on 613 canvases, 22' x 100'. Courtesy of the Artist.*

*Robert Kirschbaum. The Akedah Series: Akedah 45. 2008–09. Mixed media on paper 9 x 8. Courtesy of the Artist.*

PLATE VIII

*Creative Science Project: Johanna Bresnick and Michael Cloud. From Mouth to Mouth. 2006. Bible and gel capsules. Dimension vary. Courtesy of the Artists.*

*Marcie Kaufman. Hear Here. 2008. Archival Digital Print with Ink. 16 in. x 20 in. Berman-Bloch Collection. Opposite page: Detail.*

PLATE IX

*Marcie Kaufman. Detail,* Hear Here. *2008. Archival Digital Print with Ink. 16 in. x 20 in. Berman-Bloch Collection.*

PLATE X

PLATE XI

*Maya Zack. Living Room 2 (2D version). 2009. Digital Prints (3D virtual model anaglyphs/ 2D). sound. 4 ft. high x 10 ft. wide. Courtesy of the Artist.*

PLATE XII

Temple Emanuel, Beverly Hills. *Photo by Tom Bonner; courtesy of Rios Clementi Hale Studios.*

*Screenshot: Carving.* Inglourious Basterds. *Dir. Quentin Tarantino. Universal, 2009.*

*Screenshot: The Bear Jew.* Inglourious Basterds. *Dir. Quentin Tarantino. Universal, 2009.*

PLATE XIII

*Bill Aron. Damascus Gate. 2010. Digital Panoramic Photograph. Courtesy of the Photographer.*

PLATE XIV

Bill Aron. Market Day Outside the Damascus Gate, 2011. Digital Panoramic Photograph. Courtesy of the Photographer.

PLATE XV

*Bill Aron. The Helicopter Crash Memorial. 2011. Digital Panoramic Photograph. Courtesy of the Photographer.*

PLATE XVI

Bill Aron. Western Wall Plaza at Night. 2010. Digital Panoramic Photograph. Courtesy of the Photographer.

# Modern Architecture and the Jewish Problem: "Jewish Architecture" Reconsidered

### *David E. Kaufman*

*T*hough unfamiliar in the past, the phrase "Jewish architecture" has lately been introduced to the lexicon of Jewish culture, popping up in book-titles (and sub-titles) such as: *New Jewish Architecture from Berlin to San Francisco* (2008); *Louis I. Kahn's Jewish Architecture* (2009); *Jewish Architecture in Europe* (2010); and *Building After Auschwitz: Jewish Architecture and the Memory of the Holocaust* (2011). Beyond focusing on architectural design by and for Jews, such publications have re-opened the older and broader debate over the nature of Jewish Art. For example, in introducing the new *Posen Library of Jewish Culture and Civilization*, editor James Young raises the familiar quandary of what makes art Jewish, and layers on a series of provocative questions:

> What is Jewish art, or photography, or architecture? What makes Barnett Newman, or Philip Guston, or Mark Rothko Jewish artists? Do Newman's meditations on martyrdom constitute "Jewishness" in his work? Do Guston's reflections on identity and catastrophe make him a "Jewish artist"? . . . And architecture. Is there such a thing as "Jewish" architecture? The current generation of Jewish architects is certainly legend (think of Frank Gehry, née Frank Owen Goldberg, Richard Meier, Peter Eisenman, Daniel Libeskind, Santiago Calatrava, James Ingo Freed, Moshe Safdie, and [Robert] A. M. Stern, to name but a few of the most prominent). But what are we to make of Gehry's suggestion that the undulating steel forms for which he is so famous are inspired by the live carp his grandmother kept in a bathtub before turning it into gefilte fish?[1]

As Young observes, the present architectural field boasts a number of stars of Jewish background, and his interrogation of a "Jewish architecture" proceeds from that context. While these Jewish architects attained prominence over the past four decades, public discussion of Jewish architecture only began in earnest in the early 2000s, when several of them first offered designs for "Jewish" buildings—e.g., Frank Gehry's Jerusalem Museum of Tolerance, Daniel Libeskind's Jewish Museums in Berlin and San Francisco, and Moshe Safdie's Yad Vashem Holocaust Museum—all included in Angeli Sachs and Edward van Voolen's 2004 museum exhibition, *Jewish Identity in Contemporary Architecture*.[2] By highlighting some notable examples of the recent construction boom in new synagogues, Jewish schools, and Holocaust museums—many but not all designed by Jewish architects—Sachs and van Voolen have made the case for the emergence of a contemporary Jewish architecture. Complicating the picture, however, the catalogue includes an incisive essay by a leading historian of synagogue architecture, Samuel Gruber. At the very opening of his essay, Gruber bluntly states: "There are many Jewish architects, but there is no such thing as a 'Jewish' architecture." He later expands on the exhibition's theme of "Jewish identity in architecture," offering this formulation:

> When architects have attempted to impose Jewish identity on a building through design and decoration, this was often done in opposition to prevailing Christian forms, rather than through the embodiment of specifically calculated Jewish features or the overall adoption of something recognizable as a Jewish sensibility . . . A less common way Jewish identity has been addressed in architecture and design has been the conscious consideration, application, and integration of Jewish devices, themes, and other expressions of meaning into a building's design so that to some degree the structure not only has a Jewish function after its completion, but is in fact imbued with Jewish identity during its creation ("Jewish Identity" 23).

Gruber's first criterion of Jewishness in architectural design—that the building not look Christian—is based on a negation; whereas his second criterion—that the architect "imbue[s]" the structure with "Jewish identity"—is vague at best. While both may be valid observations, we are nevertheless left without a practical, working definition of Jewish architecture. As an architectural historian, Gruber shies away from the phrase "Jewish architecture" and leans toward a minimalist view of the phenomenon.[3] Whereas Jewish historian Gavriel Rosenfeld leans in the opposite direction, having made an exhaustive study of "Jewish architecture" in his 2011 *Building After Auschwitz: Jewish*

*Architecture and the Memory of the Holocaust.* Moving beyond his own expertise in Holocaust memory, Rosenfeld surveys the post-sixties generation of Jewish architects represented in every major movement of contemporary architecture. In particular, he highlights the modernists Richard Meier and Peter Eisenman (two of the famed "New York Five"), post-modernists Stanley Tigerman and Eric Owen Moss, neo-classicists Allen Greenberg and Robert A. M. Stern, and internationally renowned deconstructivists Libeskind and Gehry. His book offers the most extensive argument to date in support of the notion that there is such a thing as Jewish architecture. Yet contrarily, and much to his credit, Rosenfeld begins by acknowledging the problematical aspects of the rubric "Jewish architecture":

> The very idea of Jewish architecture raises many conceptual problems, most of which derive from the fact that no single style of architecture has ever existed across the vast temporal and spatial parameters of Jewish history. In the absence of a unifying style, it is unclear what the concept of Jewish architecture might mean. Does it refer only to Jewish religious structures? Or also to secular buildings used by Jews? Does Jewish architecture have to be designed by Jewish architects to qualify as Jewish? Or do synagogues created by non-Jewish architects qualify as well? What, moreover, are we to make of Jewish-designed buildings that have no specific Jewish functions? And what about structures erected due to Jewish patronage? These questions underscore the difficulty of defining Jewish architecture (2).

Many of his questions directly parallel the larger debate over the term "Jewish Art," and certainly, questions of its meaningfulness and applicability endure—as is well demonstrated in other articles in this volume—engaging historians, critics, and artists alike (see esp. Bland). Jews in the modern world have embraced the arts as never before, and the consequent proliferation of Jewish artists in many areas of modernist art has given rise to the far from settled question: ought their creations be thought of as *Jewish* Art? This paper applies the question to the artistic profession of architecture, and is my own attempt to answer the query posed by Young and Rosenfeld—what is Jewish architecture?

The characterization of any given field of endeavor as "Jewish" is highly subjective and must therefore remain inconclusive insofar as it encompasses issues of psychological proclivities, cultural sensibilities, religious memory, etc. Yet such characterizations often begin as objective statements of quantification, a more certain matter of numbers. Psychoanalysis was called the "Jewish

science" because its principal creator and nearly all its early adherents were
Jews. Hollywood has been called "an empire of their [that is, the Jews'] own," in
other words, a "Jewish industry," since the founders of all the great studios were
immigrant Jews and Jews arguably tend to dominate its culture to this day.
And diverse arenas of American popular culture such as Broadway musical
theater, pop songwriting, stand-up and television comedy, urban photography,
classical violin, abstract expressionist art, etc., have all been deemed "Jewish"
fields for the same reason—simply because Jews are so prominent in the ranks
of their practitioners. The question then follows: what of specifically Jewish
content (or at least intent) is then infused into these cultural products? In the
particular case of Jewish Art, granted, the artists are mostly Jews; but must we
then also take for granted the inference that Jewishness is at the core of their
art? To assume that it must be so *a priori* is a form of essentializing that ought
to be avoided. Nevertheless, the question of whether there is Jewish Art, in
general, and Jewish architecture, in particular, is worthy of serious consider-
ation—just as is the case when we are faced with a preponderance of Jews in
any given cultural arena.

But architecture does not fall easily into this category. Of all the artis-
tic expressions of modernism, architecture may be the one least often linked
to Jews. Whereas modern art (painting, drawing and sculpture), music, the-
ater, and literature are all often associated with Jewish artists, producers, pa-
trons, and critics, modern architecture has only sporadically been subject to
the same association. Though Jewish architects and especially patrons may be
found throughout the history of modern architecture, the conventional his-
torical narrative most often seems bereft of Jews and their particular cultural
influence. Yet Rosenfeld's narrative tips the scale the other way by privileging
the current period—during which time a significant group of Jewish architects
has emerged—and the impression is given that the field of architecture does
indeed contain many Jews. But, in the longer perspective, this is a gross dis-
tortion, both due to the actual proportion of Jewish architects, as well as the
tendency of those Jews who do find their way into the architectural profession
to downplay their Jewishness, that is, to be assimilated Jews—contrary to the
architects touted by Rosenfeld, whom he describes as self-consciously Jewish
in both their personal identity and public work.

Of course, there are always exceptions to the rule, and further exami-
nation of the subject will reveal Jewish participants in the field in sometimes
surprising ways. Louis Sullivan's partner, for instance, was a rabbi's son named
Dankmar Adler; and two of Frank Lloyd Wright's most important clients

were named Kaufmann and Guggenheim. But as these last examples suggest, one possible reason for the relative lack of Jews in modern architecture is the common reliance of architects on commissions from corporate sponsors, and especially in the past, big business was traditionally hostile to the incursion of Jews. Many of those mid-twentieth century Jews who aspired to careers in architecture would later recall the discrimination they faced from potential employers and clients in the pre-Civil Rights era. Another probable cause was the tendency of the professional field of architecture, much like its cousin engineering, to discourage Jews from attending its training schools; and for much of the twentieth century, this tendency became self-fulfilling, as Jewish architects seemed as anomalous as black quarterbacks. Though both these stereotypes have been challenged in recent decades (the 1990s and 2000s especially), for most of the preceding century "architect" was never one of the multiple professions associated with Jews—unlike doctor, lawyer, accountant, etc. As Tigerman quipped in 1982: "no archetypal Jewish Mother ever boasts of my son, the architect [as she would] 'my son, the doctor.'" Ostensibly speaking from personal experience, Tigerman further noted that "to be an architect and to be a Jew is obviously to be a schizophrenic" (Rosenfeld 224). Architecture, in sum, is not generally seen as a Jewish profession; nor did it become, until very recently, one of the forms of modern art conventionally associated with Jews.

What constitutes Jewish architecture therefore cannot be a matter of the collective influence of a significant population of Jewish architects—there is none. Instead, the Jewishness of architecture is perhaps better seen as a function of the individual relationship between an architect, his client, and the commission. Ideally, it requires more than one of these factors—i.e., a Jewish architect, Jewish patronage, or a building of Jewish function—to justify describing the architecture as "Jewish." When just one of these factors is highlighted to the exclusion of others, the suggestion of architectural Jewishness often falls short, as exemplified by Fredric Bedoire's ambitious study, *The Jewish Contribution to Modern Architecture, 1830–1930*. First published in Swedish in 1998, it was translated into English and issued by KTAV publishing house in 2004. An exhaustive survey of all Jewish-sponsored architecture in a modern historical context, the book offers a compelling account of how wealthy Jews, as patrons of the arts, have made a significant contribution to modern architecture. But does that make modern architecture "Jewish" in any meaningful sense? Bedoire tries at first to avoid the essentialist argument as he writes: "My intention is not to demonstrate a Jewish architecture, should any such thing exist"; but then he seems to contradict himself as he continues: ". . . but [I do

intend] to underscore the presence of Jewishness in European and American architecture of the nineteenth and early twentieth centuries, to show that the Western world would have looked completely different without the Jews, and that many of the most intensified and complex formal manifestations of the age are directly related to the Jewish clientele" (507). There is no such thing as "Jewish architecture," he says, but there does exist "Jewishness *in* architecture." It is a subtle distinction without significant difference. Even if there were a meaningful distinction, by privileging Jewish patronage over designer and function, the argument falls well short of establishing useful criteria for the Jewishness of modern architecture.

Rosenfeld's *Building After Auschwitz* offers a somewhat more convincing argument for the notion of Jewish architecture by utilizing all three considerations. Through much of the volume, he makes a solid case for a contemporary Jewish architecture. Only when he follows Bedoire's example and treats just one factor at the expense of the others—in this case, the Jewish background of the architect—does his argument fall flat. As I am suggesting here, the definition is far better applied when more than one of the factors is in play, operating in relation to one another. Thus, for example, Frank Lloyd Wright's well-known design for a synagogue in suburban Philadelphia—recently explored in great depth by Joseph Siry in *Beth Sholom Synagogue: Frank Lloyd Wright and Modern Religious Architecture* (2011)—fits the definition of Jewish architecture. Though designed by a non-Jewish architect, it is a Jewish-functioned or -themed building (in this case a synagogue) designed for a Jewish client and users (a Jewish congregation). As Siry discusses at length, the rabbi of the congregation, Mortimer Cohen, participated extensively in the design process, the Jewish religious expert thus becoming an active collaborator with his famous architect. "Jewishness"—Jewish themes, questions, sensibilities, values, and most of all, relationships (as in the classic theological relationship between God, Torah, and Israel)—was thereby infused throughout the dialectical process that is architectural design, and the result can quite rightly be called "Jewish architecture."

This is even more apparent when all three factors are operative, as when a Jewish architect designs a Jewish building—a building whose purpose specifically promotes some aspect of Jewish culture—for a Jewish clientele. This Jewish architectural trifecta is the focus of a number of recent studies in addition to Rosenfeld's survey, including: Moshe Safdie's *Yad Vashem: Moshe Safdie—The Architecture of Memory* (2006); Susan Solomon's *Louis I. Kahn's Jewish Architecture: Mikveh Israel and the Midcentury American Synagogue*

(2009), and Walter Leedy's *Eric Mendelsohn's Park Synagogue: Architecture and Community* (2012). In the first case, a Holocaust museum is designed by a Jewish architect—but this is not just any Holocaust museum and not just any architect. Both the museum and its architect are Israeli, adding a third dimension to the picture. The "client" in this case is the entire nation of Israel, and even more broadly, the worldwide Jewish people—for Yad Vashem was designed to be *the* central site of Holocaust memory, the Holocaust being unquestionably an event of monumental significance to Jews around the world. It furthermore serves a special function in Israel by preserving historical memory of European anti-Semitism, to which political Zionism emerged as a response.

By its very location, therefore, Yad Vashem illustrates the link between the Holocaust and the State of Israel. As the most prominent Israeli architect working internationally, Safdie was well situated to offer a design sensitive to all the issues of Jewish and Zionist history. And indeed, the design, as completed in 2005, contains much in the way of Jewish perspectives and Zionist values. For example, the structure of the main museum exhibition wing is a submerged concrete bunker, piercing the crest of a Jerusalem hilltop. As such, it has the impact of an open wound on the landscape, a permanent rupture of the natural order—evoking a characteristically Jewish way of seeing the Holocaust, as an unfathomable human tragedy and unprecedented catastrophe in both Jewish and world history. At its end, however, the linear construction flares open as a curvilinear unfolding, revealing a vista of the landscape beyond. The view presents the beauty of nature as the antithesis to human destruction, pointing us instead toward the redeeming and reviving post-Holocaust achievement of Zionism—Israel. Having given us a design that conveys the arc of Jewish history (or at least one interpretation of it) so powerfully, it is impossible to think of Safdie's Yad Vashem as anything but Jewish architecture.

Nevertheless we still must ask: should all Holocaust-themed architecture, whether museums or memorials, be properly considered *Jewish* architecture? Certainly, memory of the Holocaust is a central component of contemporary Jewish consciousness, and its tangible manifestation in architectural design is by definition an expression "of an altered Jewish self-awareness." As Sachs and van Voolen further note: "The starting point was to break the silence and anchor Jewish life and Jewish history—including the history of destruction—conspicuously in society and the urban landscape" (8). Like Rosenfeld, they automatically classify Holocaust architecture as a form of Jewish architecture. Yet there remains at least the possibility of an architecture of Holocaust memory that does not qualify as Jewish architecture. Imagine for example that the

Ukrainian government commissioned a local non-Jewish architect to build a state museum at Babi Yar. The exhibit would certainly make note of the over 30,000 Jews who were killed at the site, and perhaps part of the motivation for the building would even be to attract Jewish visitors to the Kiev area. But the building itself would still not qualify as Jewish architecture, since Jewishness would not have primarily informed the design process nor would it be present in the transaction between Jewish architect, client, and subject. Or, to cite a case that is not hypothetical: can the Anne Frank House in Amsterdam be counted as an example of Jewish architecture?—a significant, even sacred site of Holocaust memory, certainly; but Jewish architecture? I think not. From an architectural standpoint, it is a Dutch-designed building that only became associated with the tragedy of Anne Frank after the fact. Architecturally, there is nothing particularly Jewish about it. Typologically, therefore, it may be more precise to place Holocaust architecture in a separate category; for otherwise, we accede to the notion that Holocaust consciousness is the crux of Jewish identity, that it *is* Jewishness. While for some that may be true, my own predilections regarding Jewish Art and culture suggest treating Holocaust architecture as its own category, related to but generally subsidiary to Jewish architecture *per se*.

In his lengthy study of Jewish architecture, Rosenfeld ultimately divides the subject into three categories: 1) synagogue architecture; 2) Holocaust museums and memorials; and 3) all architecture designed by Jewish architects. But to my mind there is only one form of Jewish architecture that is unequivocally Jewish, and that is the architecture of the modern synagogue. This is not simply due to the generally religious character of the synagogue, for that would be tantamount to equating Jewishness with religiosity—much like the overprivileging of Holocaust consciousness noted above. Such religious practices as synagogue attendance and communal worship are a conspicuous part of Jewish religion and hence of Jewish culture, but in neither case do they constitute the single defining element of Jewish life. As with memory of the Holocaust, Jewishness cannot be reduced merely to synagogue Judaism however important a role it may play in Jewish life. Nevertheless, synagogue design ought to be considered the principal type of Jewish architecture since, conforming to the definition above, it is the most commonplace product of the interplay between Jewish sponsorship (of the congregational community) and Jewish function (the diverse needs served by a synagogue). Add a Jewish architect to the mix and it only increases the potential Jewishness of the negotiation.

Based on the foregoing, two other building types might reasonably be added to the category of Jewish architecture: the Jewish school and Jewish

community center; and in fact, both have tended to be designed in a more Jewish vein, often by Jewish architects, in recent years. Yet as I have argued above, the synagogue—more than the school and center—is the quintessential expression of Jewish architecture for at least two other reasons as well; for it is the concrete expression of *both* religious Judaism and of Jewish social and communal life, that is, it engages both sides of the Jewish equation. In the first instance, the design of a synagogue is a rare opportunity for an architect to explore the spiritual and transcendent qualities of religion, in this case of Judaism. The synagogue presents a unique architectural challenge insofar as it is at heart the Jewish equivalent of a "church": a one-room building devoted to the worship of God. None other than Philip Johnson made this point in his foreword to Rachel Wischnitzer's *Synagogue Architecture in the United States* (1955). And more recently, Young has seconded the sentiment and emphasized the religious element in Jewish architecture as follows:

> Daniel Libeskind's Jewish museum designs, to my mind, signal a return to the conceptual religious foundations of Jewish architecture. . . . That is, just as a prayer *Minyan* turns any space into Jewish sacred space, akin to the Temple of Jerusalem, "Jewish architecture" is rooted in conceptual space, constituted not by formal structural elements, walls and cornices, but by what goes on within the volume of that space. . . . In this light, Jewish architecture is less about the building's space in the landscape and more about the space such buildings open up inside us for prayer and contemplation, for our individual contemplation of the Jewish relationship to God, life, history, culture and identity. Jewish architecture consists of this exchange between Jews and the buildings they inhabit, not in a particular building design ("Daniel Libeskind's New Jewish Architecture" 60).

Religious architecture, as is the case with religion overall, is ultimately less about the formal structures built to contain religious experience and more about the aspiration to transcend such worldly constraints. The design of the synagogue, much like that of the church, has always expressed the religious dialectic between spiritual longing and divine promise. But then, the synagogue is more than a church, serving many other functions and aspects of Jewish life as well. In addition to housing religious services, the synagogue structure also contains within it all the multiplicity and complexity of Jewishness beyond religion, including: Jewish culture, education, politics, economics, ethnic variation, immigration history, public image, inter-group relations, modes of acculturation, geographic shifts, collective memory (including Holocaust

commemoration), etc. This observation is all the more valid in the modern context, for over the past two centuries, synagogue architecture has been engaged in what Wischnitzer has called "the quest for a Jewish synagogue style" (45ff.).

Rarely content to simply mimic church design and engage in an unmediated revivalism, designers of modern synagogues have consistently sought to develop a stylistic and functional language appropriate to the Jewish synagogue—that is to say, to invent a Jewish architecture. Though often unsuccessful in aesthetic terms, their results have nonetheless made a mark on the landscape of modern religious architecture, in bold and sometimes surprising ways. The quest for a modern Jewish architecture has thus mirrored the greater aspiration of Jews to make their mark in modern society and contribute to contemporary culture; the architectural quest thus serving both as metaphor and as mechanism. The following brief survey of the two hundred year history of modern synagogue design in America and elsewhere is intended to demonstrate the notion that Jewish architecture is that which expresses the Jewish experience in built form, and captures, at one moment in time, the flow of Jewish history.

Though the modern movement in art and architecture does not commence until late in the nineteenth century, the modern experience of Jews begins at least a century earlier[4]—and thus the new synagogues of the contemporary era in Jewish history can be said to manifest a certain "modernism" well before the appearance of modernism itself. In 1794, during the early years of post-Revolutionary America, the Jews of Charleston, South Carolina erected a new synagogue edifice for Congregation Beth Elohim. As later illustrated by Solomon Nunes Carvalho, the synagogue's exterior looks like a church of the period; but it conforms to traditional Jewish practice on the interior. The building thus neatly conveys the rapprochement that newly enlightened and emancipated Jews had made with the modern world: joining the general society and becoming good citizens in the public sphere, while preserving their separate identity as Jews in private. A similar duality would be demonstrated a few decades later in the 1826 Seitenstettengasse synagogue in Vienna, whose exterior is unidentifiable as a Jewish house of worship, but whose interior is a resplendent oval-shaped synagogue sanctuary. The modern synagogue therefore reflects both the successful social integration as well as the fragmented identity characteristic of the modern Jewish experience.

In addition to the modernization of the Jew, the modern synagogue would also reflect the modernization of Judaism. Erected in 1810, the "Jacobstempel"

of Seesen, Germany, became the first synagogue structure of what soon would be called "Reform" Judaism. The small private synagogue, built for the modern school founded by Israel Jacobson, was revolutionary in the arrangement of its seating, location of its *bimah* (Torah-reading platform), and inclusion of musical accompaniment (as well as a bell in its tower). Over the next two centuries, such innovations in Jewish practice, often highly contentious, would play out in the arena of synagogue design. As historian Jonathan Sarna has demonstrated, the issue of mixed seating—men and women sitting together—was particularly challenging to the builders of synagogues, and has continued to define religious boundaries—between Orthodoxy and more liberal Jewish expressions—ever since (Sarna). In the main, the history of the nineteenth century Reform synagogue, most often called a "temple," mirrors the history of modern Judaism. But it also reflects the economic progress made by Jews during the same period, especially given that upward mobility both fosters religious acculturation and spurs the "conspicuous construction" of extravagant synagogue structures—producing "cathedrals" of an enlightened Judaism that are monuments to Jewish success at the same time.

The period in architectural history preceding the modernist revolution, and to which modernism was the response, was characterized by historical revivalism. Especially in nineteenth century religious architecture, varied styles associated with various historical periods were revived to express the diversity and pluralism of modern religion and culture. Architects of Jewish buildings were inclined as well to borrow their stylistic language from the prevailing trends of the day—for two distinct reasons: first, because it allowed them to reflect the general tendency of modern Jews to assimilate to the surrounding culture; and second, because they started, as it were, with a blank slate, due to the lack of an historical style of specifically Jewish architecture that could be revived in the first place. Yet as Gruber notes above, synagogue architects did often consciously distance their work from Christian norms of religious architecture in order to express and highlight a sense of Jewish difference. For example, though exceptions can be found, rarely did synagogue architects design in the predominant church style of Gothic Revival. Instead, they moved through a century-long search for a distinctive style appropriate to both the public- and self-image of modern Jews—aspiring to an equal status with the Christian majority, yet desiring to remain distinct from Christianity at the same time.

Thus synagogue architects experimented at various times with[5]: Egyptian Revival—as in Philadelphia's Mikveh Israel of 1825; Greek Revival—as in Charleston's Beth Elohim of 1840 (built to replace the earlier structure

destroyed by fire in 1838); Romanesque Revival—as in Baltimore's Har Sinai of 1849; Moorish Revival—as in Cincinnati's Plum Street Temple of 1866; Byzantine Revival—as in New York's Temple Beth El of 1891; Roman Revival (Neoclassical)—as in New York's Shearith Israel of 1897; and so on. Sometimes historical styles were blended in eclectic fashion—as in the Romanesque/Byzantine/Moorish Herter Brothers design for New York's Eldridge Street Shul of 1886. But without focusing on the stylistic issues embodied by any one of these trends, we can say that on the whole, the nineteenth-century synagogue was a study in variability. By cycling through so many distinct styles, the synagogue established a "Zelig"-like profile of adaptability and assimilation—not unlike the modern Jew.

It was perhaps inevitable that modern synagogue architects would attempt the invention of an explicitly Jewish style—in direct response to the common observation that there was no historical architectural style associated with Jews. As early as 1849, American Jewish clergyman and newspaper editor Isaac Leeser lamented the lack of a Jewish style, as he commented on the Egyptian Revival design of the new Beth Israel of Philadelphia: "We heard something said about the style being Hebrew, but unfortunately for our reputation there are no accessible remains of our ancient buildings, wherefore our style must be more in imagination than reality" (Wischnitzer 46). The search for an identifiably Jewish style would eventually lead architects to look at the precedent of ancient Israel. One key example of this tendency was Arnold Brunner's 1901 Henry S. Frank Memorial Synagogue, also in Philadelphia. In his design, Brunner, the architect of the 1897 Shearith Israel and one of the earliest of a growing number of Jewish architects, made direct reference to the archaeological remains of ancient synagogues in Palestine, only recently excavated. Wischnitzer adds: "The architect was inspired by the ancient Galilean synagogue exterior at K'far Bir'im" (101). By linking the building to both the earlier history of synagogue architecture and to Jewish life in ancient Israel, Brunner was attempting to infuse his design with an identifiably Jewish heritage. The same strategy is employed by numerous designers of Jewish buildings today who so often incorporate Jerusalem stone as a building material that it has become a cliché.

Early in the twentieth century, there was some effort to invent a specifically Jewish architectural style—as in the 1918 B'nai Jeshurun in New York, whose designers called their Mediterranean pastiche "Semitic style." The trend enjoyed its greatest expression in Palestine itself, as the "new Jews" of the Zionist community or *Yishuv*, inspired by Ahad Ha'am's ideology of cultural

Zionism to create a modern Hebrew culture, also attempted to create a Jewish architecture. Boris Schatz, founder of the Bezalel Art School in 1906, was instrumental in this movement, and he himself played a role in the iconic design of the Tel-Aviv Gymnasium (high school). While not all architecture made in the Jewish State is necessarily Jewish, the Zionist enterprise created a situation in which Jewish architects would often design Jewish-functioned buildings (synagogues, schools, cultural centers, museums, and now including Zionist institutions as well) for a Jewish clientele (the society of the *Yishuv*)—together creating the conditions for the emergence of a Jewish architecture. The self-conscious invention of Jewish culture is, moreover, characteristic and reflective of the modern Jewish experience.

At the same time that a modern Jewish architecture was emerging in Mandatory Palestine, the Jewish diaspora was also seeing the development of new forms of Judaism and Jewish life, and hence a different movement of Jewish architecture emerged—one not based on the development of a national identity in Israel, but on religious experimentation in America. I have in mind the architecture of the early twentieth-century synagogue-center, a subject on which I have written extensively and which I will try to summarize in brief here. The synagogue-center was an innovative form of Jewish institutional life, combining the religious functions of the synagogue with the social, educational, and recreational functions of the "Jewish center" (a generic term including Jewish settlement houses, educational alliances, modern Talmud Torahs, YM/YWHAs, etc.—later, in postwar suburbia, it would generally come to be known as a "Jewish Community Center," or JCC). The synagogue-center's architecture would reflect its multiplication of function, as in Louis Allen Abramson's designs for Manhattan's Jewish Center of 1918 and the Brooklyn Jewish Center of 1920. The former hid its synagogue sanctuary and swimming pool behind the façade of an urban apartment house, and the latter contained the same multi-faceted program within a more horizontal building that would jokingly be called a "shul with a pool." In both cases, as in the hundreds of imitations around the city and across the country, these newly characteristic institutions perfectly captured the multiplicity of modern Jewish life. In the Jewish past, such multiple functions were served by a panoply of institutions; but in the American present, the "department store" mentality had taken hold, whereby all possible needs would be served under one roof. In this sense, the synagogue-center and its Progressive-era architecture together embodied the modern rationalization of Jewish life. The principal underlying motivation no longer prioritized fealty to God and adherence to *Halakha* (Jewish Law)

but rather tended to focus more on the efficient servicing of individual and communal needs. One such rationalist expression of modern Judaism was Rabbi Mordecai Kaplan's program of "Reconstructionism," which, to a certain extent, was inspired and first enacted by his early experimentation with the synagogue-center idea (Kaufman).

Following World War II, Jewish communities on both sides of the Atlantic embraced the modernist style of architecture. Its application to the modern synagogue has been well documented (e.g., Solomon ch. 1), but let us focus here on how it reflects postwar Jewish life. The first great modern synagogue architect was Erich Mendelsohn, who was himself a refugee from Nazi Germany and thus personified the post-Holocaust Jewish experience. As Gruber put it: "The very act of building his (six) major synagogue designs was a sign of the Jewish phoenix rising from the ashes" ("Jewish Identity" 26). His design for St. Louis' B'nai Amoona Synagogue (1947), for example, combined the earlier functionalist rationalism of the synagogue-center with the more expressionist emotionalism of modern art and architecture. This design-duality might perhaps be read to reflect the tension between the extraordinary optimism and the extreme despair, which together characterized the twentieth century, a tension especially acute for postwar Jews who lived in the shadow of the Holocaust but who also witnessed the establishment of the State of Israel. Similarly, another major Jewish architect of the time, Louis Kahn, incorporated the complexity inherent in modern Judaism in his (unbuilt) designs for Mikveh Israel in Philadelphia (c. 1962). As one of the most revered of modern architects, Kahn is best known for his use of natural light, which he considered the most essential element in architecture. Of course, light also happens to be a central metaphor in Jewish tradition, evoking both the divine "light" of the Torah as well as the modern intellectual culture of the Jewish enlightenment. In his chapter on Kahn, Rosenfeld also shows how the secular architect may have found inspiration in the historical precedents of the ancient Temple in Jerusalem and of the symbology of the *Kabbalah* (Jewish mysticism) in his later synagogue designs. In Kahn's designs as in Mendelsohn's, the progressive ideals of modernist architecture were employed to express the inherently conservative values of traditional Judaism.

Two other Jewish architects, less famous than Mendelsohn and Kahn, but whose works might better reflect the American Jewish experience, must be cited here as well: Percival Goodman and Sidney Eisenshtat. The one based on the east coast, the other in the west, they together encapsulate the synagogue building boom of postwar suburbia. Goodman, surely the most prolific of

American synagogue architects, is credited with over "50 synagogues and religious buildings around the United States, including the stone-clad Fifth Avenue Synagogue at 5 East 62d Street in Manhattan; Congregation Adath Israel in the Riverdale section of the Bronx, a strongly sculptural mass of concrete and red brick, and Shaarey Zedek in Detroit, a building with a stark prowlike concrete roof cutting into the sky." *New York Times* architecture critic Paul Goldberger further notes: "His synagogues were assertive, modernist structures, reflecting Mr. Goodman's belief that the vocabulary of modern architecture could be transformed into something rich enough to express powerful religious feeling. . . . His goal was to design synagogues that interpreted Jewish tradition in modern ways, and he saw the architect as critical to the process of expressing religious identity in the 20th century." Most of Goodman's synagogue designs, as in his 1954 Temple Beth El of Providence, Rhode Island, tended to be more intimate and human-scaled spaces than Mendelsohn's and more practical and functional than Kahn's. One of his main contributions was his emphasis on the artistic program of the new suburban synagogues. Goodman encouraged his congregational clients to adorn their new synagogues with artistic decoration and symbols of the Jewish religion. Though unintended, the new emphasis on décor and symbolism echoed the detachment of postwar Jews from Judaism. Their Jewishness was no longer an outgrowth of an organic Jewish culture, but was instead a conscious choice to add a little Judaism to their suburban existence. The ubiquitous parking lots of the commuter community synagogues signified something similar—the "drive-in" quality of suburban Judaism. Once again, modern synagogue architecture is "Jewish" insofar as it reflects the modern Jewish experience.

The work of Eisenshtat is perhaps an even better exemplification of "Jewish architecture." In addition to the synagogue projects he completed in Southern California and elsewhere, Eisenshtat also undertook commissions to design other "Jewish" buildings in the Los Angeles area such as the Hillel House at USC (from whose School of Architecture he had graduated in 1935), the Westside Jewish Community Center, the House of the Book at the Brandeis-Bardin Institute (c. 1970), the University of Judaism master plan (completed, 1977), and even the Friar's Club in Hollywood (1961). His noted synagogues include Los Angeles' Temple Emanuel (1951) and Sinai Temple (1959), as well as B'nai David of Detroit, Michigan (1956) and Temple Mount Sinai in El Paso, Texas (1962). An Orthodox Jew, Eisenshtat was said to refuse payment for his synagogue projects. He also claimed to approach synagogue design from a distinctly Jewish perspective, pointing out that "people pray differently. For

instance, in Catholicism, priests are intermediaries of God; in Judaism there is no intermediary. Therefore, I see the structure for synagogues not as pyramidal but as horizontal" (De Wolfe). Hence most of his sanctuary designs employ a circular plan, a common feature of synagogue architecture intended to simultaneously express the unity of God's creation and the egalitarian nature of Jewish worship and assembly. Clearly influenced by Mendelsohn, and described both "as an expressionist and as a minimalist," Eisenshtat endowed his synagogues with an especially dramatic quality, befitting the revivalism of postwar Judaism (Gruber, "Sidney Eisenshtat").

*Figure 1.* Temple Emanuel, Beverly Hills. *Courtesy Temple Emanuel of Beverly Hills.*

But Eisenshtat's most significant representation of American Jewish life might just be posthumous. In 2011, the congregation that gave him his first synagogue commission, Temple Emanuel of Beverly Hills, completed an extensive renovation and restoration of their landmark 1951 building (fig. 1; for a photograph of the modern renovation done by Rios Clementi Hale Studios, see Pl. XII). Funded largely by members of the congregation in the film industry, and guided by the combined vision of Rabbi Laura Geller, Building Committee chair (and Hollywood producer) Scott Stone, and architect Mark Rios, the renovation has been largely deemed a success (Rus). One of its more remarked-upon features was the renewal of many of the original artistic works adorning the synagogue exterior and interior. Wall sculptures, stained glass windows, and interior murals that had been obscured for years were suddenly

"revealed" and "seen" as if for the first time. Perhaps the best example is the colorful mosaic mural created by Joseph Young in 1955 for the entry vestibule of the synagogue. The mural portrays the multiple functions of the ideal synagogue, representing the postwar synagogue-center as a house of prayer, study, and assembly. Also, as noted at the time, the work was "considered to be the first major mosaic installed in a Jewish Temple since ancient Biblical times."[6] Hidden by grime and ignored for decades, the Young mural is now a newly appreciated highlight of the restored Temple Emanuel. Similarly, the reconfigured sanctuary has reinvigorated congregational worship and to a significant degree, re-energized the communal life of Emanuel. In sum, the temple renovation in Beverly Hills beautifully represents the revival of American Judaism and the transformation of the American synagogue, taking place at the turn of the twenty-first century. Once again, synagogue architecture (and art) can be seen to reflect its broader cultural context.

Finally, we come to the more recent efflorescence of Jewish architects. Whether their creative output ought to be considered a form of Jewish architecture has been the guiding concern of this essay. As suggested earlier, the Jewish origins of the architect alone provide no assurance of the Jewishness of the architecture. Beyond the question of origins, more careful observers pay attention to the actual life experience of the architect and his/her own relationship to questions of Jewishness. Despite Rosenfeld's cataloging of numerous contemporary Jewish architects, this can be seen most clearly in the career arcs of three in particular: Stanley Tigerman, Peter Eisenman, and Daniel Libeskind. Rather than being known for designing synagogues, all three have themselves raised the relevance of being Jewish to the practice of architecture, and thus contemplated the possibility of a Jewish architecture. According to Rosenfeld, "Eisenman's development as a Jewish architect was prompted by his agreement to produce a design for the Jewish Museum of San Francisco in 1996"; and quotes Eisenman as follows:

> For the San Francisco project, Eisenman sought to create what he called a "new kind of Jewish architecture." Eisenman's ideas for San Francisco were concerned with "the Jewish situation as we approach the 21st century—post-Holocaust." As he put it, the building "should be an expression of what it means to be a Jew—morally, spiritually, culturally," . . . Eisenman concluded [in his letter to the museum committee], it was "wrong" to ask the question: "How can a Jewish Museum express its Jewishness?" Especially "since the history of Jewish building . . . has been explicitly against any overt symbolism,

> any so-called graven images, . . . it would seem quite natural," he
> concluded, "that the architecture of this museum [would] be ques-
> tioning rather than expressing." (172)

Eisenman was relating his own postmodern and deconstructivist im-
pulses as an architect to the process-oriented and open-ended nature of the
Jewish rabbinic tradition embodied in Oral Torah. Something like the intricate
inter-textual practice of Jewish study, contemporary architectural practice re-
sists straight lines, right angles or conclusive answers, urging us instead to con-
sider every side of a question. Remarkably, given their history of assimilation,
contemporary Jewish architects have begun to relate this aspect of Jewish tradi-
tion to their avant-garde designs, whether or not the building serves a Jewish
purpose. In this regard the self-reflexive Jewish declarations of Tigerman,
Eisenman, and Libeskind suggest that they may be seen as exemplars of a
Jewish architecture. If the defining feature of contemporary Jewish life is the
individual search for Jewish identity, and if the main arbiter of contemporary
Judaism is "the sovereign self" (Cohen and Eisen), then such personal evoca-
tions of architectural intent are what make their work reflective of contempo-
rary Jewish experience. In the end, it is not Frank Gehry's use of the [gefilte]
fish motif in his architecture that makes it Jewish; it is his own musing over
its source, his own wrestling with the enigma of his Jewish identity, that im-
plies a Jewish architecture. Yet like the aforementioned three postmodernists,
Gehry's to-this-date failure to take a synagogue commission (he may perhaps
have grown too big—though that did not stop Frank Lloyd Wright or Phillip
Johnson) indicates that something essential is missing from his trajectory as
a Jewish architect. As we have seen in this brief survey, the phenomenon of
Jewish architecture is best seen in the design and construction of synagogues—
for the simple reason that a synagogue, which etymologically means "place of
*syn*thesis," serves to unite the individual Jew with the Jewish community and
to submerge the ego-driven self within the spiritual collectivity of "*Am Yisrael*"
(the Jewish people).

In the final analysis, the individualistic architectural musings I have just
described do not truly conform to my thesis that Jewish architecture is that
which mirrors the greater Jewish experience. For minus the element of a *col-
lective* Jewishness, neither architects nor architecture (nor any other art) can
ever fully be thought of as "Jewish." To make the point as clearly as possible,
let us compare the phrase "Jewish architecture" to the more familiar "Gothic
architecture." It would appear faintly ridiculous, would it not, to define Gothic
architecture as the design product of an individual Goth architect working

out the anomalies of his "Goth-ish" identity. Yet Jewish architecture is routinely defined in such terms. The definition works to a degree, as the modern Jewish experience has tended to reduce Jewishness to the level of individual consciousness and thus created the category of Jewish "identity." Hence the term "Jewish architecture" is often conceived of as the expression of an architect's Jewish identity in his/her design. As suggested here, such a definition has now become the most common compensation for the lack of a recognizably Jewish style of architecture. But just as "Gothic" now refers to the entirety of a medieval civilization, so too should the term "Jewish" more accurately reflect all its social, political, cultural, communal and religious associations. Jewish architecture is best understood not as the individual intimation of an assimilated and idiosyncratic Jewish sensibility, but rather as the more holistic expression of a collective Jewish experience, a shared Jewish culture, in all its complexity and fullness. A Jewish architecture has indeed begun to emerge at the turn of the twenty-first century—but rather than thinking of it merely as the product of an architect who happens to be a Jew, it makes far better sense to see it as the artful manifestation of our contemporary Jewish civilization.

## Notes

1. Also see Young's parallel discussion in "Daniel Libeskind's New Jewish Architecture" 45–46.
2. The exhibition was held at the Joods Historisch Museum in Amsterdam.
3. Personal correspondence, 26 July 2012.
4. Many contemporary Jewish historians have suggested a periodization for Jewish modernity beginning earlier than the late eighteenth century; see esp. Meyer ch. 1, "When Does the Modern Period of Jewish History Begin?"
5. My examples will all be American, but European buildings could be cited just as well.
6. Quoted from the original news item reproduced on the *Facebook* page for Temple Emanuel Beverly Hills (Joseph L. Young fan page).

## Works Cited

Bedoire, Fredric. *The Jewish Contribution to Modern Architecture, 1830–1930.* New York: KTAV, 2004.

Bland, Kalman. *The Artless Jew: Medieval and Modern Affirmations and Denials of the Visual.* Princeton: Princeton Univ., 2001.

Cohen, Steven M. and Arnold Eisen. *The Jew Within: Self, Family, and Community in America.* Bloomington: Indiana Univ., 2000.

Cohen-Mushlin, Aliza and Harmen H. Thies, eds. *Jewish Architecture in Europe.* Petersberg: Imhof, 2010.

De Wolfe, Evelyn. "AIA Honors Five Southland Architects." *Los Angeles Times* 13 April 1986.

Gabler, Neil. *An Empire of Their Own: How the Jews Invented Hollywood.* New York: Anchor, 1988.

Goldberger, Paul. "Percival Goodman, 85, Synagogue Designer, Dies." *New York Times* 12 October 1989.

Gruber, Samuel. "Jewish Identity and Modern Synagogue Architecture." *Jewish Identity in Contemporary Architecture.* Eds. Angeli Sachs and Edward van Voolen. Munich: Prestel, 2004.

———. "Sidney Eisenshtat, 90, Leading Synagogue Architect." *The (Jewish Daily) Forward* 1 April 2005.

Johnson, Philip. "Foreword." *Synagogue Architecture in the United States.* Rachel Wischnitzer. Philadelphia: Jewish Publication Society, 1955.

Kaufman, David E. *Shul with a Pool: The "Synagogue-Center" in American Jewish History.* Waltham, MA: Brandeis Univ., 1999.

Leedy, Walter. *Eric Mendelsohn's Park Synagogue: Architecture and Community.* Kent, OH: Kent State Univ., 2012.

Meyer, Michael. *Judaism Within Modernity: Essays on Jewish History and Religion.* Detroit: Wayne State Univ., 2001.

Rosenfeld, Gavriel David. *Building After Auschwitz: Jewish Architecture and the Memory of the Holocaust.* New Haven, CT: Yale Univ., 2011.

Rus, Mayer. "Back to Shul." *Los Angeles Times Magazine.* December 2011.

Sachs, Angeli and Edward van Voolen, eds. *Jewish Identity in Contemporary Architecture.* Munich: Prestel, 2004.

Safdie, Moshe. *Yad Vashem: Moshe Safdie—The Architecture of Memory.* Zürich: Müller, 2006.

Sarna, Jonathan. "The Debate over Mixed Seating in the American Synagogue." *The American Synagogue: A Sanctuary Transformed.* Ed. Jack Wertheimer. Waltham, MA: Brandeis Univ., 1987. 363–94.

Siry, Joseph. *Beth Sholom Synagogue: Frank Lloyd Wright and Modern Religious Architecture.* Chicago: Univ. of Chicago, 2011.

Solomon, Susan G. *Louis I. Kahn's Jewish Architecture: Mikveh Israel and the Midcentury American Synagogue.* Waltham, MA: Brandeis Univ., 2009.

*Temple Emanuel, Beverly Hills.* 1950s. Courtesy Temple Emanuel of Beverly Hills.

Wischnitzer, Rachel. *Synagogue Architecture in the United States: History and Interpretation.* Philadelphia: Jewish Publication Society, 1955.

Wolf, Connie, ed. *Daniel Libeskind and the Contemporary Jewish Museum: New Jewish Architecture from Berlin to San Francisco.* San Francisco: Contemporary Jewish Museum, 2008.

Young, James E. "Daniel Libeskind's New Jewish Architecture." *Daniel Libeskind and the Contemporary Jewish Museum: New Jewish Architecture from Berlin to San Francisco.* Ed. Connie Wolf. San Francisco: Contemporary Jewish Museum, 2008.

———. "Introducing The Posen Library." 29 Sept 2012 <http://www.posenfoundation.com/literaryprojects/posenlibrary.html>.

Young, James E., ed. *Posen Library of Jewish Culture and Civilization.* New Haven: Yale Univ., forthcoming.

# Jewish Revenge Fantasies
# in Contemporary Film

*Daniel H. Magilow*

## TURNING JEWS INTO NAZIS?

Dustin Hoffman almost turned down the role of Thomas Babington, aka "Babe," Levy, the Jewish graduate student and long-distance runner in John Schlesinger's 1976 thriller *Marathon Man*, because he objected to the original script's ending. As the narrative unfolds, Levy unwittingly becomes ensnared in an international intrigue involving Nazi war criminals and diamonds stolen from Jews imprisoned at Auschwitz, and, in one memorable scene, Nazi dentist Dr. Christian Szell (villainously played to the hilt by Laurence Olivier) tortures him by extracting his teeth without anesthesia. The original script had Hofmann's character avenging this torture and shooting Szell at the film's end, but Hoffman said he would not take the part if it demanded that his Jewish character kill a Nazi. In Hoffman's words, "I won't become a Nazi to kill a Nazi. I won't demean myself." Screenwriter William Goldman eventually rewrote the script so that Szell dies when he accidentally stabs himself during the final climactic scene (Pogrebin 16).

This anecdote is a reminder that the notion of post-Holocaust Jewish vengeance has long sparked criticism for "turning Jews into Nazis." This objection has recently come into the spotlight anew because of a recent spike in the appearance of Jewish revenge fantasies that have appeared over the last dozen years. Jewish revenge fantasies are films or scenes within films in which avenging Jews enact stylized, spectacular, and typically graphic violence upon their clichéd cinematic enemies, usually Nazis but sometimes Arabs or others. These post-Holocaust wish-fulfillments have appeared in genres as diverse as comic book adaptations (*X-Men: First Class*, 2011), spy thrillers (*Munich*, 2005 and

*The Debt*, 2010) and even comedies (*The Hebrew Hammer*, 2003 and *You Don't Mess with the Zohan*, 2008).

As much as any revenge fantasy, *Inglourious Basterds*, filmmaker Quentin Tarantino's 2009 homage to World War II and the "platoon" films made about it, has polarized critics for graphically and violently "turning Jews into Nazis." In one scene, a member of the eponymous all-Jewish platoon called the "Basterds" clubs a German prisoner to death. This he-man (or to use the appropriate Yiddish term, *shtarker*), known as "The Bear Jew," points his baseball bat at the German's Iron Cross and asks "Did you get that for murdering Jews?" When the German officer smugly responds "for bravery," The Bear Jew bludgeons him to death while playfully pretending to be the Boston Red Sox great Ted Williams, slugging a home run at Fenway Park. Near the film's conclusion, the Basterds machine-gun Hitler, Goebbels, and other top Nazis during the premier of a propaganda film in occupied Paris. The theater has also been locked shut and set aflame, and as the Nazis burn alive, an avenging Jewess addresses the audience from a film-within-a-film onscreen and proclaims, "This is the face of Jewish vengeance." *Inglourious Basterds* ends as one of the Basterds carves a swastika into a Nazi's forehead as a kind of permanent mark of Cain (cf. Gen 4:15) (fig. 1; Pl. XII). "I think this just might be my masterpiece," he states with a distinct air of self-satisfaction.

*Figure 1. Screenshot: Carving.* Inglourious Basterds. *Dir. Quentin Tarantino. Universal, 2009.*

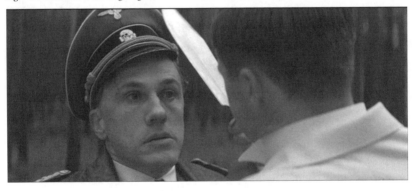

Unlike *Marathon Man*, which avoided representing Jewish vengeance and relied instead on its protagonist's ability figuratively and literally to run away, Tarantino's counterfactual take on the history of World War II and the Holocaust marks a significant change from stereotypical cinematic images of

Jews as helpless victims of Nazi violence. Some critics, such as Roger Ebert, have applauded *Inglourious Basterds* for rejecting realism as the only legitimate idiom through which to engage traumatic history and for instead providing "World War II with a much-needed alternative ending." Yet others find its Jew-on-Nazi violence offensive. They see it as one of many recent films that purportedly trivialize or profane the Shoah or, worse, are tantamount to Holocaust-denial, because they establish moral equivalency between violence by Jews and Nazis. These objections resemble those cited by Dustin Hoffman in 1976. Writing in *The New Yorker*, David Denby stresses that, "In a Tarantino war, everyone commits atrocities." The scholar and critic Daniel Mendelsohn shares this objection and faults *Inglourious Basterds* for inverting perpetrator and victim roles. "In history," he writes: "Jews were repeatedly herded into buildings and burned alive . . .; in *Inglourious Basterds*, it's the Jews who orchestrate this horror. In history, the Nazis and their local collaborators made sport of human suffering; here, it is the Jews who take whacks at Nazi skulls with baseball bats, complete with mock sports-announcer commentary, turning murder into a parodic 'game'. And in reality, Nazis carved Stars of David into the chests of rabbis before killing them; here, the 'basterds' carve swastikas into the foreheads of those victims whom they leave alive." For Mendelsohn, the problem with the film is the same as it was for Hoffman: it turns Jews into Nazis and thus by implication, Nazis into Jews.

This critical outrage merits further examination because such disgust for *Inglourious Basterds* arises from the view that the film is "the latest, if most extreme, example of a trend that shows just how fragile memory can be—a series of popular World War II films that disproportionately emphasize armed Jewish heroism . . . and German resistance, . . . or elicit sympathy for German moral confusion . . ." (Mendelsohn). The greater issue around revenge fantasies is that critics tie them to Holocaust inversion, the ahistorical rhetorical trick that equates Jews (usually Israelis) with Nazis, often to advance anti-Semitic or anti-Zionist agendas. In a 2010 interview with the Scottish university newspaper *The Student*, Nazi hunter Efraim Zuroff called Holocaust inversion "far more dangerous" than outright Holocaust-denial and cited *Inglourious Basterds* as an example (McGloin). Writing in *Commentary* in February 2006, Gabriel Schonfeld called Steven Spielberg's *Munich* (about a team of Mossad agents, who avenge the 1972 Munich Olympics massacre) "treacherous," "hypocritical," and "a phony balance sheet."

In this essay, however, it is my aim to refute the notion that Jewish revenge fantasies "turn Jews into Nazis" and suggest instead that implicit political

considerations undergird hostility to them of the sort noted above. Critics of revenge fantasies regularly point to these films' lack of historical authenticity and suffuse their attacks with exaggerated fears about the loss of the Holocaust's lessons and legacies. Yet behind this putative lament about historical inauthenticity as the main objection lurks a demand for politically acceptable Holocaust representations, which is to say, representations that help perpetuate an aura of uniqueness around the Holocaust such that it might be employed as a critical tool for diverse political and social agendas. These agendas do not break down into simple left/right areas of political interest. Rather, they run the gamut from the views of arch-Zionists, who might use the Holocaust as a visceral means to justify Israeli policies, all the way to the claims of anti-Semites and anti-Zionists, who also "need" the Holocaust in order to accuse Zionists of recreating it. Such extreme positions often rely on a quasi-sacred notion of the Holocaust that aims to set it above and beyond the inevitably politicized realm of cultural representation. In contradistinction to this understanding, I argue that revenge fantasies articulate an aspiration to break free of the constraints that filmic representations of Holocaust victimhood have placed on Jewish identity.

Criticizing Jewish revenge fantasies for "turning Jews into Nazis" ignores this trend's critical potential to reflect what I take to be a significant shift in the attitude of both the producers of contemporary films and their audience. What has become clear, upon examining these films closely, is that they endeavor to transcend the well established reluctance to act out Jewish rage, along the lines noted above. Rather, they show how the very parameters of socially acceptable Holocaust representation are changing as living links to the Shoah grow scarcer and traumatic memory becomes further dislocated from its historical bases. In the following pages, I will first examine how entrenched aesthetic demands placed on Holocaust representations have effectively proscribed representations of Jewish rage. Then, through close readings of the revenge fantasies in *X-Men: First Class* and *Inglourious Basterds*, I will make the case that we miss the point if we read them simply as historically inaccurate, voyeuristic spectacles or callous examples of Holocaust inversion.

The value of Jewish revenge fantasies lies instead in their status as meta-commentaries. One might say that, with malice aforethought, they calculatingly distance themselves from the usual defining goal of Holocaust films, which film historian Annette Insdorf distils as that of "finding an appropriate language for that which is mute or defies visualization" (xv). Rather, their value arises from the ways in which they satirically or at least self-consciously cite, invert, and overstate conventional cinematic representations of Jews. In

so doing, to use scholar Eric Kligerman's phrasing, they "dismantle . . . the reified modes of representing catastrophic history and Jews themselves, and provoke . . . the spectator to think anew questions pertaining to these representations" (139). This, then, becomes a means of contesting the stereotypes of Jewish identity and historical experience by endowing Jewish characters with exaggerated violent behavior that—while typical, normal, and expected from the onscreen gentile enemies of the Jews—had previously been cinematically construed as quintessentially un-Jewish. Rather than simply dismiss revenge fantasies as morally relativistic films in which Jews become equated with Nazis and which therefore blur the historical record, we would do better to read their foregrounded mode of antirealism as a critical gesture meant to reveal the overly simplistic double-standard portrayed by clichéd images of Jews as inherently peaceful or passive versus their enemies, who are portrayed as naturally, even inherently, violent.[1]

## PROHIBITIONS ON REPRESENTING JEWISH RAGE

To explain the absence until recently of Jewish revenge fantasies and their recent recrudescence, it is necessary to consider two related factors that have effectively stigmatized this kind of film. The first is a broader social proscription against representing Jewish rage after the Holocaust and the second a more medium-specific set of unwritten rules around Holocaust films that have long discouraged filmmakers from addressing rage and revenge and stigmatized those who have.

To the first point: narratives of Jewish vengeance do not mesh well with broader tendencies to Americanize Holocaust representations, to tell the history of Jewish victimhood through redemptive Christological narratives that emphasize "turning the other cheek," and transform an ethnically specific genocide into a drama where there is a clear-cut, moral dichotomy of wholly good victims versus utterly evil perpetrators (Flanzbaum; Roskies). To the contrary, they frustrate the desire, so often reflected in Holocaust films, to redeem the Shoah by casting it as a universalized morality tale about the dangers of intolerance. If a film appears to blur moral distinctions between "evil Nazi perpetrators" and "good Jewish victims," it threatens the Holocaust's status as what Jeffrey Shandler characterizes as the "master moral paradigm" of American life (xvii). Because of this tendency to memorialize the Holocaust in ways that

allow posterity to instrumentalize it for contemporary political and social agendas, a stigma has become attached to representations of Jewish rage, even historically accurate ones.

One finds a characteristic instance of the taboo around representations of Jewish rage in the memoirs of Holocaust survivor and writer Elie Wiesel. The story behind Wiesel's international bestseller *Night* (1960) typifies the history of downplaying Jewish sentiments for vengeance in art and literature and concurrently establishing a more passive, martyr-like figure as the archetypical survivor. In "Elie Wiesel and the Scandal of Jewish Rage," Naomi Seidman has shown how Wiesel replaced the ethnic specificity and angry tone of his 1954 Yiddish-language memoir *Un di velt hot geshvign* (in English, *And the World Remained Silent*) with the more gentile-friendly French-language version, *La Nuit* (1958), the basis of the English translation *Night*. Seidman points to a controversial passage at the book's end describing how liberated Jewish prisoners from Buchenwald behaved after liberation. In *Un di velt hot geshivgn*, Wiesel writes, "Early the next day Jewish boys ran off to Weimar to steal clothing and potatoes. And to rape gentile girls [un tsu fargvaldikn daytshe shikses]. The historical commandment of revenge was not fulfilled" (Vizel, [Wiesel] *Un di velt* 244, cited in Seidman 6). The French and English versions render the passage as "dormir avec des femmes" and "to sleep with local girls" phrasings that imply consent, not rape, rage, and revenge. Seidman reads this editing as symptomatic of a broader attempt to soft-peddle Jewish history to the conservative postwar social and political norms of an overwhelmingly gentile readership. The anger, desire for vengeance, and tone of historic specificity in the Yiddish version takes on a more passive, metaphysical feel in translation. Wiesel and other Jews may have publicly muted sentiments for vengeance, but these feelings clearly persisted, even if they were confined to Jewish circles. They permeated literature created within wartime ghettos, most famously Hirsh Glik's *Partizaner Lid*, and persisted in Holocaust memorial (*yizker*) books. For instance, the *yizker* book commemorating Brzezany, Poland includes an anecdote about "The Avenging Jew—Yankel (Yankale) Fenger," who was "a mysterious figure who took revenge of the *goyim* for every act of hurting Jews" (Zlatkes 452). Similarly, the *Yizker-bukh Chelm* includes a Yiddish-language poem simply entitled "Nekome, nekome!" (Revenge, revenge!) (Bakalczuk 585–86).

The atypical nature of episodes of revenge does not by itself account for the absence of cinematic Jewish revenge fantasies. Indeed, popular Holocaust films disproportionately focus on atypical stories, particularly exceptional stories of survival by Jews such as *Europa Europa* (1990), *Schindler's List* (1993),

*The Pianist* (2002), *The Counterfeiters* (2007) or, in the case of Germans, valiant anti-Nazi resistance, as in *Sophie Scholl: die letzten Tage* (2005) or *Valkyrie* (2008). One must instead consider a second major impediment to the widespread depiction of Jewish rage and the concurrent tendency to downplay Jewish anger and emphasize Jewish passivity. This impediment has been codified in unwritten rules for representing the Shoah.

The scholar Terence Des Pres identified "three basic commandments" that artists, writers, and especially filmmakers have felt the need to follow if they wanted to be taken seriously. According to Des Pres, a Holocaust representation's legitimacy has long depended on how successfully it approaches the genocide 1) as historically unique, 2) with historical accuracy, and 3) in a solemn and serious way. Film historian Aaron Kerner argues that these protocols have significantly limited what sorts of cultural artifacts are even considered Holocaust films. Following Millicent Marcus and Imre Kertész, Kerner suggests that such rules have promoted a form of "Holocaust fundamentalism" or "Holocaust conformism" (Kerner 1–2). Holocaust films can easily become formulaic exercises that foreclose genuinely critical investigations of history and memory in favor of a lazy reliance on aesthetic orthodoxies that fetishize historical authenticity yet fail to render it in a truly realistic manner. These unwritten but reified standards condition how filmmakers address the Holocaust if they desire respectability or even acknowledgment. The criticisms around *Inglourious Basterds* are typical for those films that take liberties with Holocaust history or that approach it irreverently. They are quickly dismissed and subsumed under a critical discourse that labels them as irresponsible, historically inaccurate, tasteless, insensitive, and fodder for Holocaust deniers.

Recent Jewish revenge fantasies regularly run afoul of Des Pres's rules, particularly in their demand for fidelity to the historical record. Revenge fantasies are in part "historically inauthentic" because of the scarcity of episodes of post-Holocaust Jewish vengeance. Anecdotes exist about armed Jewish *Nokmim* ("avengers"), unrealized revenge plots to poison Munich's water supply, and former Nazis found murdered in roadside ditches or hanging from nooses in staged suicides (see, e.g., Elkins; Cohen). But such episodes were exceptions to the rule. Elie Wiesel explained this absence of widespread revenge in his 1996 memoir *All Rivers Run to the Sea*:

> Jewish avengers were few in number, their thirst for vengeance brief. . . . Jewish survivors had every reason in the world to seize weapons and go from city to city, village to village, punishing the guilty and terrorizing their accomplices. The world would have said

nothing, everyone would have understood. But with the exception
of a few units of the Palestinian Jewish Brigade who swept through
Germany tracking down and punishing the murderers of our people,
the Jews, for metaphysical and ethical reasons rooted in their history,
chose another path . . . (142).

While Wiesel credits Jewish morality for stemming violent reprisals, his-
torian David Cesarini attributes it to the more banal matter of logistics. More
of the guilty were not punished, Cesarini notes, "because it would have been
a never-ending task" (Freedland). But whether metaphysics or pragmatics ac-
count for the lack of episodes of Jewish revenge, we are left with a syllogism
that would seem to explain the absence of cinematic revenge fantasies when
matched with the tendency to represent Jewish victims as passive martyrs: if
a Holocaust film's aesthetic legitimacy depends on its willingness to tell the
truth, and if one truth of the Holocaust is that Jews were overwhelmingly vic-
tims rather than avengers, then Holocaust films must first and foremost narrate
the story of the Holocaust as a story of Jewish victimhood.

## THE RETURN OF THE JEWISH REVENGE FANTASY—*X-MEN: FIRST CLASS* AND *INGLOURIOUS BASTERDS*

The absence of post-Holocaust films in which the Nazis get their comeup-
pance has never been absolute. For instance, Lawrence Baron points to films
between 1944–59 that subjected Nazi war criminals to "trial by audience."
Aaron Kerner points to films with more explicit violence, notably pulp thrillers
such as Zbyněk Brynych's 1967 film *Já, spravedlnost* (*I, Justice*, about a group of
Czechs who kidnap and torture Hitler after discovering that the *Führer* faked
his suicide), *The Odessa File* (1974, in which a freelance journalist infiltrates
and unravels an organization of unrepentant Nazis after the war) and *The Boys
from Brazil* (1978, about the cloning of Hitler) (75). But where these films were
sporadic exceptions, in which the avengers were also not necessarily Jewish,
the last decade or so has seen a steadier flow of revenge fantasies with Jewish
protagonists. In *The New Jew in Film*, in fact, Nathan Abrams argues that,
"films in which Jews fight back during the Shoah, setting out to reverse the rep-
resentation of European Jews as simply helpless passive victims of the Nazis,
proliferate in contemporary cinema" (117). Consider some examples that, to
greater and lesser extents, thematize muscular Judaism and Jewish vengeance:

- Steven Spielberg's *Munich* (2005) tells a story of Mossad agents who systematically hunt down and assassinate the Palestinians responsible for the murder of the Israeli athletes at the 1972 Olympics;

- Paul Verhoeven's *Black Book* (2006) concerns a Dutch Jewess cabaret singer who joins the resistance, infiltrates the Nazi occupation government in wartime Netherlands, and uses her feminine wiles to avenge her family's murder by the Nazis;

- *Defiance* (2008) dramatizes the story of Jewish partisans in Belorussia. Director Edward Zwick based the film on Holocaust scholar Nechama Tec's true story of the Bielski brothers and stated that he made the film to correct the misimpression engendered by the past sixty years of Holocaust movies that "all Jews went meekly to the ovens" (Arnold);

- Director John Madden's *The Debt* (2010), an adaptation of Assaf Bernstein's 2007 Israeli film of the same name, follows a team of Mossad agents in 1965 that infiltrates East Germany to kidnap a Nazi doctor, who used Jews in horrific medical experiments;

- In Jonathan Kesselman's farce *The Hebrew Hammer* (2003), comically stylized hard-boiled Jewish private investigator—"a certified circumcised private dick"— named Mordechai Jefferson Carver fights to prevent Santa Claus's evil son Damian from destroying Hanukkah and monopolizing the Christmas season exclusively for Christians.

What emerges from this cursory list is not only the variety of genres (war films, spy thrillers, comedy), but also the variety of the representational modes. Where films such as *Defiance*, *Munich* and both versions of *The Debt* operate in distinctly realist idioms, *X-Men: First Class* and *Inglourious Basterds* make few claims to mimesis. For this reason, conservative critics are quick to read the latter types as evidence of Holocaust-denial, inversion, or trivialization—since these films brazenly violate the unwritten rules. The criticism is not entirely

fair, because even putatively "realistic" films regularly take their own liberties
with history in order to maintain the aura of uniqueness around the Holocaust
that makes it amenable to instrumentalization for political ends. *Defiance*, for
instance, utterly sidesteps the issue of the Bielski partisans' potential complicity
in the Naliboki massacre of Poles in 1943 in favor of a more black-and-white
depiction of Jewish victimhood transformed into vengeance (cf. Brostoff). The
"antirealist" revenge fantasies in particular demand analysis because they sug-
gest that as the memory of the genocide becomes increasingly available only
through mediated forms rather than memory of direct historical experience,
attitudes that demand strict realism and all due reverence are changing.

In the remainder of this essay I will examine how two "antirealist" Jewish
revenge fantasies, in particular—*X-Men: First Class* and *Inglourious Basterds*—
suggest that this broadening of approaches to Holocaust representations cor-
responds to widespread fatigue with familiar depictions of Jews as victims. In
a recent essay, Jackson Katz notes that audiences' positive responses to two re-
cent Jewish revenge fantasies, *Defiance* (2008) and *Inglourious Basterds* (2009),
"suggests that a generational shift may be underway in how Jewish-American
men (and women) approach the topic of historic Jewish victimization: by con-
structing and nourishing a counter-narrative of violent Jewish resistance to
Gentile (including Arab and Muslim) violence" (71). Central to this shift is
the rejection of stereotypical notions of Jewish masculinity as frequently rep-
resented in the past in popular Holocaust cinema, which is to say, men who
are weak and victimized. In addition to Ben Kingsley's accountant character
in *Schindler's List*, for instance, whom critic Ilene Rosenzweig dubbed "the
king of the Jewish wimps," other examples include Roberto Benigni's clever
neurotic in 1997's *Life is Beautiful*; Adrian Brody's Academy Award-winning
portrayal of Władysław Szpilman, the sensitive artist and title character of
Roman Polanski's 2002 *The Pianist*; and Jack Scanlon as Shmuel, the "Boy in
the Striped Pajamas" from the 2008 film of the same name, who is quick to
forgive a betrayal by his gentile counterpart Bruno even when it causes an SS-
man to beat him brutally (Rich). The violent Jews in *X-Men: First Class* and
*Inglourious Basterds* invert these images, not in a revisionist spirit whose aim is
to violate the truth of Jewish victimhood, but rather more as calculated depar-
tures that play off films that have long depicted Jews as the "ultimate victims,"
thus developing a competitive model of memory (Rothberg 3).

## *X-MEN: FIRST CLASS*—A COMIC BOOK REVENGE FANTASY

In explaining his use of comics as the medium for his genre defying work *Maus* (1986, 1991), Art Spiegelman points to Holocaust cinema's propensity for realism: "Most dramatic films have a hard time with the Holocaust as a subject because of the medium's tendency toward verisimilitude and reproduction of reality through moving photographic images. Holocaust movies usually look like they're populated by fairly well-fed inmates, for example" (*Metamaus* 166). While director Michael Vaughn's *X-Men: First Class* (2011) is obviously not a cartoon, at least in a literal sense, this comic book adaptation's utilization of "comic book like" exaggerations create a useful medium through which to cite iconic tropes, settings, and dialogue of Holocaust films as a way to draw attention to their reified character. Just as Spiegelman uses animals to represent ethnicities and nationalities, *X-Men: First Class* distills characters into types, notably superheroes and villains who further serve as proxies for moral positions.

*X-Men: First Class* begins in the clichéd cinematic space that metonymically embodies the Holocaust: Auschwitz. Conforming to the conventions of superhero comics, it opens with the origin story of the mutant super-villain Magneto (Michael Fassbender). In this opening scene, a Josef Mengele-like Nazi doctor, Klaus Schmidt (Kevin Bacon) murders the mother of the young Jewish boy Erik Lensherr, when Erik fails to demonstrate his mutant powers of telekinesis. The casting of the prolific actor Kevin Bacon as Schmidt elicits an effect of disassociation because Bacon has appeared in so many different genres. Popular audiences recognize Bacon from films such as *Footloose*, *Wild Things*, or *JFK*, and thus his role as a hyperbolically evil Nazi doctor strips away the gravitas from *X-Men: First Class* by acknowledging its status as a filmic commodity. Where Schmidt is exaggeratedly evil, Lensherr and his mother are also stock Holocaust characters, both weak and effeminate.

In the rest of the film, Lensherr, now known as Magneto and in full command of his ability to manipulate metals from a distance, seeks out Schmidt (now known by the alias Sebastian Shaw), who has escaped to South America after the war. The film features two notable revenge fantasy scenes that exaggerate and invert both Jewish stereotypes and the trite tropes of Holocaust cinema. In one early scene, Magneto travels to Switzerland to find out information about Shaw's whereabouts. When the Nazi-accommodating Swiss banker plays dumb and refuses to reveal any information, Magneto uses his mutant power to extract the banker's tooth-filling. This dental torture mimetically reenacts Nazi violence against Jews and the desecration of Jewish corpses by scavenging

their teeth for dental gold. Even more to the point, it conspicuously inverts the most infamous scene of *Marathon Man*. There, Laurence Olivier's character, the Nazi dentist Christian Szell repeatedly asks Dustin Hoffman's character Babe Levy "Is it safe?" a code phrase that Levy does not understand. Levy is the height of Jewish passivity—he does not physically resist as a Nazi tortures him and can only try to end the pain through his cleverness, as when he states "yes, it's safe" in the hope that this response will appease the Nazi doctor. *X-Men: First Class* radically turns inside-out the passivity of the earlier film. Although Magneto could use his mutant power in any number of ways to torture the dentist, he chooses to reenact the specific form of Nazi violence against a Jew from *Marathon Man*. This cinematic citation invites critical viewers to understand *X-Men: First Class* not simply as a voyeuristic fantasy, but as an active challenge to reified images of Jewish victimhood in Holocaust films. The film is not re-writing the Holocaust—mutant heroes and villains with comic book superpower make it clear that authenticity and historical revisionism are not the point. Rather, *X-Men: First Class* is one of many films that challenges the virtual monopoly that Holocaust films have long maintained on the way Jewish identity is represented to mass audiences and, by implication, the use and even abuse of that image for various political ends.

In a second revenge fantasy scene, Magneto travels to South America in the early 1960s in search of Sebastian Shaw, much as Israeli agents did in order to capture Adolf Eichmann. While Magneto does not find Shaw, he does find some of the war criminal's accomplices in a bar in a small village. The scene exaggerates and parodies the *mise-en-scène* and iconography of other cinematic genres. As one would expect in a "saloon brawl," evocative of westerns and spy thrillers, the tense dialogue within a cramped space slowly builds suspense before the inevitable explosion of violence. In a nod to the visual tropes of Holocaust cinema, Magneto exposes the concentration camp prisoner tattoo on his forearm to reveal his identity right before the violence begins. Magneto then uses his telekinesis to murder Shaw's accomplices in a manner that symbolically reenacts anti-Semitic stereotypes. He makes them aim and shoot their (metal) guns at each other and manipulates a knife to nail an unrepentant Nazi's hand to a wooden table before killing him. Through this protracted, symbolic crucifixion, Magneto would seem to reenact and even embrace the stereotype of the Christ-killing Jew.[2] The scene recycles the reified cinematic iconography of Nazism: the Germans drink beer from large steins, and the dagger used in the symbolic crucifixion bears the SS motto "Meine Ehre heißt Treue" ("my honor is loyalty") to reinforce the Nazis' standing as villains. The

Nazis are exaggerated, comic book types—at once cold, unrepentant, and superhumanly evil.

These scenes show how *X-Men: First Class* does not simply "take liberties with history." Understanding its comic book form is critical for understanding its content, because the exaggerations, to which comic books give license, expose the film's political dimensions. By underscoring the novelty of portraying Jewish vengeance, the scene invites viewers to reflect critically on it. And many have. Writing in *Haaretz*, Doron Fishler reads Magneto's trauma—his use of the clichéd phrase "Never Again!" his statement that he is Frankenstein's monster in search of his creator, and his ultimate failure to end a cycle of violence and retribution—as a critical meditation on the history of the state of Israel (Fishler).

## *INGLOURIOUS BASTERDS*—THE BEAR JEW AS A CINEMATIC PASTICHE

As with the comic book science fiction thriller *X-Men: First Class*, the form of *Inglourious Basterds* activates a critical dialogue with the history of World War II and Holocaust films. The Bear Jew scene cited at the beginning of this essay typifies Tarantino's *modus operandi*, which is to reconstitute popular film genres in a pastiche. Just as Tarantino recycled the motifs and narrative conceits of Hong Kong kung fu and Japanese sword fighting (*chanbara*) films in his *Kill Bill* series (2003, 2004) and paid homage to the Blaxploitation genre in *Jackie Brown* (1997), *Inglourious Basterds* teems with citations from Holocaust and World War II films, Spaghetti westerns, and Nazisploitation movies. Its title deliberately misspells Enzo Castellari's 1978 mission film *Quel maledetto treno blindato*, released in English as the correctly spelled *The Inglorious Bastards*. Because he peppers his films with B-movie references, Tarantino has invited criticism for privileging film historical references over history itself.[3]

However, this self-referential focus on cinematic history is the space of the film's critical politics. Like other Jewish revenge fantasies, *Inglourious Basterds* rejects the demand for verisimilar representation. The liberties it takes with history are central to its ability to produce alienation effects in audiences and encourage them to rethink their image of Jewish identities. The ways the setting, music, and dialogue of The Bear Jew episode invert film history and recode Jewish masculinity epitomize how revenge fantasies violate the taboo

on representing Jewish rage. Tarantino creates a Jewish male who is less stereo-typical than the victimized Jewish males in other recent Holocaust films when his pathological and psychopathic behavior disrupts audience expectations. This disruption of expectations creates an opportunity to reflect on them.

From the outset, the scene's setting draws attention to itself as spectacle. Brad Pitt's character Sgt. Raine, the gentile leader of the otherwise Jewish unit known as the "Basterds," welcomes a captured German officer's refusal to di-vulge enemy positions. Raine knows the only recourse will be to call in The Bear Jew to execute the German. This possibility pleases him because "[W]atchin' Donny [Donny Donowitz, aka, "The Bear Jew"] beat Nazis to death is the closest we ever get to goin' to the movies." With such dialogue, the film points to the status of World War II and Holocaust films as entertainment, whatever pretensions they may harbor as historical documentation or vehicles of witness-bearing.

*Figure 2. Screenshot: The Bear Jew.* Inglourious Basterds. *Dir. Quentin Tarantino. Universal, 2009.*

As The Bear Jew enters the scene to execute the German (fig. 2; Pl. XII), dramatic and suspenseful but historically dislocated music produces an alien-ation effect. Composed by Ennio Morricone and entitled "La Resa," Italian for "the Surrender," this soundtrack was featured in Sergio Sollima's 1966 Spaghetti Western *La Resa dei conti*, meaning "the settling of accounts" but released in English as *The Big Gundown*. Visually, The Bear Jew scene directly mimics the shots of *La Resa dei conti*, even though Sollima's film is a western about a vigilante lawman who tracks down a Mexican peasant accused of raping and murdering a young girl—seemingly, a far cry from a Holocaust film. Through Morricone's music, however, the scene draws attention to the way that films about the Shoah, like pulp westerns, are fundamentally commodities, whatever

their pretensions as serious artworks or social commentaries. The ominous music begins to play after Sgt. Raine has called in The Bear Jew from his cave (the tunnel) to kill the German officer. Tarantino builds tension by extending the scene of the avenger emerging from the cave. One expects to see a monster, a bear, or other creature worthy of the low-pitched, powerful brass music, but when The Bear Jew is revealed as the conspicuously Semitic-featured actor and horror film director Eli Roth, viewers are again invited to reflect on the genre they are seeing and on their expectations of what Jews should look like. Quite simply, The Bear Jew would appear to be not the monster that the music sets him up to be, at least not at first glance.

Like the setting and the music, the scene's stock characters and well-worn dialogue parody the staples of World War II and Holocaust films. The Bear Jew scene draws attention to the fossilized nature of dialogue in World War II and Holocaust films by exaggerating it and by inverting the power relationships in which characters manifest clichés. The captured German officer repeatedly switches generic types. When asked to reveal German positions, he first performs as the honorable officer and platitudinously states, with hand on heart, "I respectfully refuse." After refusing demands to tell the Americans where the Germans have set up snipers nests, he morphs into another cliché of Holocaust films: the zealous anti-Semite who screams "fuck you and your Jew dogs!" in a frothing rage. Such dialogue draws attention to screenwriting conventions by inverting the power dynamics in which such familiar dialogue is spoken. In revenge fantasies, Jews use these ready-made phrases to ritually humiliate Germans just as Germans have been humiliating Jews in decades of Holocaust films. For his part, The Bear Jew also shifts roles. Just before he becomes the psychopathic embodiment of Jewish rage, he stops to remind us that this is not how we usually see him. Seconds before he clubs the German to death, he cocks his head slightly to the side and we see not the face of a violent killer, but a tender look characteristic of the "gentle Jew" stereotypes. But just as quickly, he switches roles. Holocaust films have long presented Germans as utterly indifferent to Jewish death, and here, The Bear Jew takes on this same blasé attitude. He callously shouts mock sports-announcer commentary as he clubs the German to death, coarsely screaming "Teddy Fucking Williams knocks it out of the park!" The callousness and casual disregard for human life is so gratuitously exaggerated that it loudly points to the possibility of other kinds of Jews than just victims.

## JEWISH REVENGE FANTASIES AND JEWISH CULTURAL
## ASPIRATIONS

In the broadest sense, Jewish revenge fantasies like those depicted in the scenes from *Inglourious Basterds* and *X-Men: First Class* are nothing new. Indeed, Paul Wegener's *The Golem* (1920), a canonical moment of early film, explicitly concerns the Golem as an avenging figure of Jewish myth. Nonetheless, the recent boom of Jewish revenge fantasies clearly speaks to a more recent history, specifically that of the post-Holocaust stigmatization of Jewish rage. It often seems as though there is no alternative to the vicious circle, in which Jewish characters are perpetually relegated to cinematic victimhood or, if they morph from victims into victimizers, they then garner criticism for "stooping to the level of the Nazis."

As we have seen, this type of filmic gamesmanship, whose moves play with and against the clichés of cinematic history opens up a critical space that displaces the dichotomy between reality and revenge fantasy of the Shoah, even if ongoing controversies bespeak the entrenched status of social and aesthetic conventions about Holocaust representation. We can reasonably read this shift as embodying the desire that Jewish identity be represented on-screen in a manner that accords with the increasing diversity of Jewish experience and identity in the early-twenty-first century. Jewish revenge fantasies embody the cultural aspirations of this younger generation that Caryn Aviv and David Shneer have termed "The New Jews." According to Aviv and Shneer, the "New Jews" no longer view themselves through the received identity categories of the past, especially the dichotomies of the rootless, effete, passive, Yiddish-speaking Jew of the diaspora contrasted to the rooted, masculine, active, and Hebrew-speaking Zionist. "The New Jews" perceive a sense of rootedness in diverse geographic and cultural settings and embrace more free-spirited interpretations of Jewish identity. One ultimate goal for these younger generations would seem to be that they want neither to be perpetrators nor victims, but to escape any such stereotypical categories that then tend to become the inflexible bases for political agendas. Jewish revenge fantasies simply represent one dazzling aspect of that cultural aspiration.

## Notes

1. In that a broader discussion of the history of representations of Jewish masculinity exceeds the bounds of this essay, see also Boyarin; Breines; Rosenberg.

2. This image was recently buttressed in Mel Gibson's *The Passion of the Christ* (2004), a film that has grossed over $600 million and been criticized for its anti-Semitic imagery. See Fredriksen; Garber.

3. Austin Fisher argues that Tarantino's constant allusions to other films are divorced from their original socio-political contexts. Tarantino has "sealed them within the hermetic world of movie quotations inhabited most conspicuously by Tarantino" (200).

## Works Cited

Abrams, Nathan. *The New Jew in Film: Exploring Jewishness and Judaism in Contemporary Cinema*. New Brunswick: Rutgers Univ., 2012.

Arnold, William. "Action-packed 'Defiance' Tells a Thrilling Tale of Jewish Resistance to the Nazis." *Seattlepi.com* 15 Jan 2009. 8 Oct 2012 <http://www.seattlepi.com/ae/movies/article/Action-packed-Defiance-tells-a-thrilling-tale-1297583.php#src=fb>.

Aviv, Caryn S. and David Shneer. *New Jews: The End of the Jewish Diaspora*. New York: New York Univ., 2005.

Bakalczuk, Mellech, ed. *Yisker-bukh Chelm*. Johannesburg: Chelmer landsmanshaft in Johannesburg, 1954. 8 Oct 2012 <http://yizkor.nypl.org/index.php?id=1866>.

Baron, Lawrence. "Trial by Audience: Bringing Nazi War Criminals to Justice in Hollywood Films, 1944–1959." *After the Holocaust: Challenging the Myth of Silence*. Ed. David Cesarani and Eric J. Sundquist. New York: Routledge, 2011. 152–69.

*Black Book* (*Zwartboek*). Dir. Paul Verhoeven. B-Film Distribution, 2006.

*Boy in the Striped Pajamas*. Dir. Mark Herman. Walt Disney, 2008.

Boyarin, Daniel. *Unheroic Conduct: The Rise of Heterosexuality and the Invention of the Jewish Man*. Berkeley: Univ. of California, 1997.

*The Boys from Brazil*. Dir. Franklin J. Schaffner. Fox, 1978.

Breines, Paul. *Tough Jews: Political Fantasies and the Moral Dilemma of American Jewry*. New York: Basic, 1990.

Brostoff, Marissa. "Polish Investigators Tie World War II Partisans to Naliboki Massacre." *Haaretz.com* 14 Aug 2008. 8 Oct 2012 <http://www.haaretz.com/print-edition/features/polish-investigators-tie-world-war-ii-partisans-to-naliboki-massacre-1.251792>.

*Já, spravedlnost* (*I, Justice*). Dir. Zbyněk Brynych. Ustredni Pujcovna Filmu, 1967.

Cohen, Rich. *The Avengers: A Jewish War Story*. New York: Viking, 2001.

*The Counterfeiters* (*Die Fälscher*). Dir. Stefan Ruzowitzky. Filmladen, 2007.

*The Debt*. Dir. Assaf Bernstein. Tricoast Worldwide and Elephant Films, 2007.

*The Debt*. Dir. John Madden. Focus and Miramax, 2010.

*Defiance*. Dir. Edward Zwick. Paramount Vantage, 2008.

Denby, David. Rev. of *Inglourious Basterds*. *The New Yorker* 24 Aug 2009. 8 Oct 2012 <http://www.newyorker.com/arts/critics/cinema/2009/08/24/090824crci_cinema_denby?currentPage=all>.

Ebert, Roger. Rev. of *Inglourious Basterds*. *Chicago Sun-Times* 20 Aug 2009. 8 Oct 2012 <http://rogerebert.suntimes.com/apps/pbcs.dll/article?AID=/20090819/REVIEWS/908199995>.

Elkins, Michael. *Forged in Fury*. New York: Ballantine, 1971.

*Europa Europa*. Dir. Agnieszka Holland. Orion, 1990.

Fisher, Austin. *Radical Frontiers in the Spaghetti Western: Politics, Violence and Popular Italian Cinema*. London: Tauris, 2011.

Fishler, Doron. "Magneto and the Jewish Question." *Haaretz* 1 July 2001. 8 Oct 2012 <http://www.haaretz.com/weekend/magazine/magneto-and-the-jewish-question-1.370702>.

Flanzbaum, Helene. *The Americanization of the Holocaust*. Baltimore: Johns Hopkins Univ., 1999.

*Footloose*. Dir. Herbert Ross. Paramount, 1984.

Fredriksen, Paula, ed. *On The Passion of the Christ: Exploring the Issues Raised by the Controversial Movie*. Berkeley: Univ. of California, 2006.

Freedland, Jonathan. "Revenge." *The Guardian* 26 July 2008. 10 Oct 2012 <http://www.guardian.co.uk/world/2008/jul/26/second.world.war>.

Garber, Z., ed. *Mel Gibson's Passion: The Film, the Controversy and Its Implications*. West Lafayette: Purdue Univ., 2006.

*The Golem*. Dir. Paul Wegener. Universum Film, 1920.

*The Hebrew Hammer*. Dir. Jonathan Kesselman. Strand, 2003.

*Inglourious Basterds*. Dir. Quentin Tarantino. Universal, 2009.

Insdorf, Annette. *Indelible Shadows: Film and the Holocaust*. 3rd ed. Cambridge: Cambridge Univ., 2003.

*Jackie Brown*. Dir. Quentin Tarantino. Miramax, 1997.

*JFK*. Dir. Oliver Stone. Warner Bros., 1991.

Katz, Jackson. "Not So Nice Jewish Boys: Notes on Violence and the Construction of Jewish-American Masculinity in the Late 20th and Early-21st centuries." *Brother Keepers: New Perspectives on Jewish Masculinity*. Ed. Harry Brod and Shawn Zevit. Harriman, TN: Men's Studies, 2010.

Kerner, Aaron. *Film and the Holocaust: New Perspectives on Dramas, Documentaries, and Experimental Films*. New York: Continuum, 2011.

*Kill Bill*. Dir. Quentin Tarantino. Miramax, 2003–2004.

Kligerman, Eric. "Reels of Justice: *Inglourious Basterds, The Sorrow and the Pity* and Jewish Revenge Fantasies." *Quentin Tarantino's* Inglourious Basterds: *A Manipulation of Metacinema*. Ed. Robert von Dassanowsky. New York: Continuum, 2012.

*La Resa dei conti* (*The Big Gundown*). Dir. Sergio Sollima. Columbia, 1966.

*Life is Beautiful*. Dir. Roberto Benigni. Miramax, 1997.

McGloin, Catherine. "The Battle for Truth." *The Student* 2 Feb 2010: 11. 10 Oct 2012 <http://issuu.com/student_newspaper/docs/week-4--the-student---semester-2---20092010>.

Mendelsohn, Daniel. " 'Inglourious Basterds': When Jews Attack." *Newsweek* 14 Aug 2009. 10 Oct 2012 <http://www.thedailybeast.com/newsweek/2009/08/13/inglourious-basterds-when-jews-attack.html>.

Morricone, Ennio. "La Resa" ("the Surrender"). Soundtrack for *La Resa dei conti* (*The Big Gundown*). Dir. Sergio Sollima. Columbia, 1966.

*Munich*. Dir. Steven Spielberg. Universal, 2005.

*The Odessa File*. Dir. Ronald Neame. Columbia, 1974.

*Partizaner Lid (Zog Nit Keyn Mol).* Lyrics by Hirsh Glik, 1943. Music by Pokrass, Dmitri and Daniel Glik. 1935.

*The Passion of the Christ.* Dir. Mel Gibson. Newmarket, 2004.

*The Pianist.* Dir. Roman Polanski. Focus and Universal, 2002.

Pogrebin, Abigail. *Stars of David: Prominent Jews Talk about Being Jewish.* New York: Broadway, 2005.

*Quel maledetto treno blindato (The Inglorious Bastards).* Dir. Enzo Castellari. Capitol, 1978.

Rich, Frank. "Extras in the Shadows." *New York Times* 2 Jan 1994. 10 Oct 2012 <http://www.nytimes.com/1994/01/02/opinion/journal-extras-in-the-shadows.html>.

Rosenberg, Warren. *Legacy of Rage: Jewish Masculinity, Violence and Culture.* Amherst, MA: Univ. of Massachusetts, 2001.

Roskies, David G. *Against the Apocalypse: Responses to Catastrophe in Modern Jewish Culture.* Syracuse: Syracuse Univ., 1999.

Rothberg, Michael. *Multidirectional Memory: Remembering the Holocaust in the Age of Decolonization.* Stanford: Stanford Univ., 2009.

*Schindler's List.* Dir. Steven Spielberg. Universal, 1993.

Schoenfeld, Gabriel. "Spielberg's *Munich.*" *Commentary* Feb 2006. 10 Oct 2012 <http://www.commentarymagazine.com/article/spielberg's-"munich">.

*Marathon Man.* Dir. John Schlesinger. Perf. Dustin Hoffman, Laurence Olivier. Screenplay by William Goldman. Paramount, 1976.

Seidman, Naomi. "Elie Wiesel and the Scandal of Jewish Rage." *Jewish Social Studies* 3.1 (Autumn 1996): 1–19.

Shandler, Jeffrey. *While America Watches: Televising the Holocaust.* New York: Oxford Univ., 2000.

*Sophie Scholl—Die letzten Tage (Sophie Scholl—The Final Days).* Dir. Marc Rothemund. X Verleih and Zeitgeist, 2005.

Spiegelman, Art. *Maus I: A Survivor's Tale: My Father Bleeds History.* New York: Pantheon, 1986.

———. *Maus II: A Survivor's Tale: And Here My Troubles Began.* New York: Pantheon, 1991.

———. *Metamaus.* New York: Pantheon, 2011.

*Valkyrie.* Dir. Bryan Singer. Metro-Goldwyn-Mayer, 2008.

Wiesel, Elie. *All Rivers Run to the Sea: Memoirs.* New York: Knopf, 1996.

———. *La Nuit.* Paris: Minuit, 1958.

———. *Night.* New York: Hill and Wang, 1960.

———. (Eliezer Vizel). *Un di velt hot geshvign (And the World Remained Silent).* Buenos Aires: Tsentral-Farband fun Poylishe Yidn in Argentine, 1956.

*Wild Things.* Dir. John McNaughton. Columbia, 1998.

*X-Men: First Class.* Dir. Michael Vaughn. Fox, 2011.

*You Don't Mess with the Zohan.* Dir. Dennis Dugan. Columbia, 2008.

Zlatkes (Rosenblat), R. *Narajow ve-ha-seviva; toldot kehilot she-nehrevu*. Ed. Menachem
    Katz. Trans. R. Erez. Haifa: Brzezany-Narajow Societies, 1978. 10 Oct 2012 <http://
    www.jewishgen.org/yizkor/berezhany/ber450.html#452-1r>.

# Temporal Shifts in Multi-Image Panoramas of Israel: A Personal Reflection

## Bill Aron*

My connection to Judaism has always informed my life and my work. In the 1970s, when I was living in New York City, I was fascinated by the Lower East Side and its history of being one of the principal areas of settlement for Jews as they immigrated to this country around the turn of the last century. The first Jews came in 1650 and by 1920, the area contained the largest Jewish community in the world.

Equally fascinating for me, while living on the Upper West Side, was a group called the New York *Havurah*. The members of the *Havurah* were committed to practicing Jewish traditions in new and alternative settings. The *Havurah* had no affiliations, either with a particular synagogue or with one of the movements within Judaism. Members were committed to traditional Judaism, but were concerned with making it more democratic and egalitarian, and less institution-bound.

These were the subjects of my first two portfolios. Other photographers advised me not to concentrate on Jewish themes; they warned that I would get stigmatized as the "Jewish" photographer. I remember thinking, "Wow, that would be great." Only one photographer, the Israeli Micha Bar Am, urged me to pursue what captured my attention and imagination. I have never regretted following his advice and being labeled as the "Jewish" photographer.

Several years ago, I came to understand that digital imaging and imagery were altering the medium of "professional photography," radically and

permanently. With the advent of new and better generations of digital cameras and a wide variety of software programs available for editing and manipulating photographs, anyone, it seemed, could create their own art, even their own commercial photographs. In fact, I began to wonder if there was still a place for me as a photographer. This led me to step back to study and explore how the digital revolution could be applied to my photography in a way that made sense to me. Many factors can differentiate a photograph from a snapshot. One that is important to me is a consideration of "perspective." What happens when you change the angle of view, or walk around to the side, or even to the back of your subject? How do the meaning and the mood of the photograph change? An essential exercise in the classes that I teach is to have my students shoot what they see, and then change something like the camera angle and/or the perspective, and shoot the same scene again.

About four years ago I came across the multi-image panoramas of Israeli photographer Barry Frydlendar. I was intrigued because of what this technique enabled me to do with perspective by flattening a circular, panoramic plane of as much as 360 degrees. Previously, I had always respected the frame, the borders of the photograph. If the image had to be cropped, then it was not good enough. Constructing a panorama of many images was very different from my previous work, and almost antithetical to my ideas about the frame. I now had to ask myself: "What would happen to my photography if I strung together multiple images?" Additionally, once I made the leap to more than one image in the same frame, "how would the order of the images, or the timing of them, affect the outcome?"

I found that there were several photographers working with this technique, most dealing with nature or some aspect of the landscape. Not many included street scenes with people. Variations included harsh edges between the sections of the panorama, or softened edges. Seeing their work helped me formulate a starting point. After a number of months of experimentation, I arrived at a method with which I felt comfortable.

The technique I prefer involves shooting many overlapping images of a scene, continuously, up to 360 degrees, but not necessarily a fully circular view. This might involve ten to twenty, or even more, images for a single setting. I then stitch them together into a panorama so that the junctures between the images appear seamless. I also leave the outer edges of the panorama alone, not cropping to make them even (an homage to my previous way of working). Another way I like to work is to revisit a particular place on subsequent days, shooting from the same spot, and then selecting the "slices" that I want from

each day, before blending the images together. With this approach to visualization in mind, I began to look for appropriate subjects that would especially benefit from this new technique.

I have always felt close to Israel. In college, I participated in the American Friends of Hebrew University junior year abroad program. Whenever we can, my wife, Isa, and I travel to Israel from Los Angeles, where we live. I am proud of my past images of Israel, single frames capturing an instant in time; hopefully my vision as an artist made them more profound than the details contained within the frame. As the late photographer, Gary Winogrand, famously articulated: "The photograph should be more interesting or more beautiful than what was photographed" (Diamonstein 187).

I always find Israel inspiring. The blend of cultures is exciting. The vistas are remarkable. The colors and the light are unlike any other place I have ever been. Also as a Jew and a photographer the subject of Israel allowed me to explore in depth the Jewish preoccupation with time. The concepts of time and timelessness and their self-conscious juxtaposition seem to me to be central to Judaism. The tradition has many ways to view time simultaneously on synchronic and diachronic levels, as is implicit in a phrase like "We came out of Egypt" rather than "Long ago our ancestors came out of Egypt." With those thoughts in mind, I set out to think and work in the new panoramic format.

As I began to experiment with this technique, I noticed that people would appear as many as three or four times in the panoramas due to their walking through the scene as I was shooting the overlapping images. *The Helicopter Crash Memorial*, 2011, is one example of this (fig. 1; Pl. XV). It seemed to me, at first, that this presented an image of past, present and future, all at the same time. One of my mentors, after looking at some of the panoramas, suggested that I read some philosophers who speak about a *tenseless* time, and who raise the question, "Can we actually experience *tense*?"

*Figure 1. Bill Aron. The Helicopter Crash Memorial. 2011. Digital Panoramic Photograph. Courtesy of the Photographer.*

Our conventional expectation is that time passes. Time is transient. Viewed in this way, one might argue that there is no enduring present. As soon as we perceive the present, it is past. The present has no duration. In the image *Market Day Outside the Damascus Gate*, 2011, the group around the man in the yellow shirt appears three times (fig. 2; Pl. XIV). Which is past, which is present, and which is future? Are they all past because they are recorded in a photograph?

*Figure 2. Bill Aron.* Market Day Outside the Damascus Gate. *2011. Digital Panoramic Photograph. Courtesy of the Photographer.*

There are a number of philosophers[1] who think and write about competing notions of time. A group called the "Presentists," or A-Theorists, claim that the use of "tense" is essential to all discourse about time. The distinctions between them are essential, and all time involves an ordering of change; for example 2011 is always before 2012. An event is first part of the future, then the present, and then the past. That which has been perceived is in the past, and that which will be perceived is in the future.

Another group called the "Eternalists," or B-Theorists, grant equal reality to all tenses. Our conventional notion of time, they say, is merely a subjective, and fabricated structure to understand "before, now and later." They wish to eliminate all talk of past, present and future in favor of a "tenseless" ordering of time. Tense is obliterated. The people walking through the image are doing it in the present, or the past, or the future. There is no tense to what they are doing. One philosopher, in writing about the "Unreality of Time," concludes by

stating that "Our ground for rejecting time . . . is that time cannot be explained without assuming time" (McTaggart).

This understanding of conflicting notions of time, of putting past and present in the same image, has enabled me to once again see Israel in a new and different way. Visitors to Israel often remark on how eternal it seems. The trees, rocks, buildings, and even shadows bear witness to history. Digital photography has enabled me to convey that sense of the eternal by revealing what our eyes and brain cannot fathom on their own. A photograph always has to be a visualization of the past, as that scene was when it was present. The panorama, by combining the same people as they are photographed at several different points in time, embedded within the ancient environment, conveys that sense of past and present together, and gives a visualization of the timelessness of the entire scene.

In summary, I began this process by attempting to find a new "place" for myself as a photographer. I found that place by standing still and having time move around me.

The Norwegian poet, Olav Hauge, said it best, I think:

> Today I saw
> two moons,
> one new
> and one old.
> I have a lot of faith in the new moon.
> But it's probably just the old (61).

## Notes

*.   *Bill Aron.* 18 Oct 2012 <http://www.billaron.com>.
1.   For the following discussion, see, e.g., McTaggart.

## Works Cited

Aron, Bill. With an introduction by Chaim Potok. *From the Corners of the Earth: Contemporary Photographs of the Jewish World.* Philadelphia: Jewish Publication Society, 1985.

_____. *Damascus Gate.* 2010. (See Pl. XIII)

_____. *The Helicopter Crash Memorial.* 2011.

_____. *Market Day Outside the Damascus Gate.* 2011.

_____. *Western Wall Plaza at Night.* 2010. (See Pl. XVI)

Diamonstein, Barbaralee. "Garry Winogrand." *Visions and Images: American Photographers on Photography.* New York: Rizzoli, 1982.

Hauge, Olav. "Today I Saw." *The Dream We Carry; Selected and Last Poems of Olav H. Hauge.* Trans. Robert Bly and Robert Hedin. Townsend, WA: Copper Canyon, 2008.

McTaggart, J. M. E. "The Unreality of Time." *Mind: A Quarterly Review of Psychology and Philosophy* 17 (1908): 456–73.

# About the Contributors

**LISA ANSELL** is Associate Director of the Casden Institute for the Study of the Jewish Role in American Life at the University of Southern California. She received her BA in French and Near East Studies from UCLA and her MA in Middle East Studies from Harvard University. She was the Chair of the World Language Department of New Community Jewish High School for five years before coming to USC in August, 2007.

**BILL ARON** has long been known as a a chronicler of Jewish communities throughout the world, as well as an environmental portrait photographer. His photographs have been exhibited in major museums and galleries throughout the United States and Israel. His work has also appeared in a wide variety of publications, and is found in numerous public and private collections. His first book, *From the Corners of the Earth* (Philadelphia: JPS, 1987), with an introduction by Chaim Potok, chronicles the Jewish communities of Russia, Cuba, Jerusalem, New York and Los Angeles. A second volume of his work, *Shalom Y'all* (Chapel Hill: Algonquin, 2002), has an introduction by Alfred Uhry. He has also produced multi-image panoramas of urban scenes in Israel, which have been exhibited in Boston and New York. Bill lives in Los Angeles where he is undoubtedly the only freelance photographer with a PhD in sociology. More at: www.billaron.com.

**MATTHEW BAIGELL** is Emeritus Professor of Art History at Rutgers University. He has authored, co-authored, edited, and co-edited twenty books on American art, Jewish American art, and contemporary Russian art. His recent books include *American Artists, Jewish Images* (Syracuse: Syracuse Univ., 2006), *Jewish Art in America: An Introduction* (Lanham, MD: Rowman & Littlefield, 2007). He co-edited *Jewish Dimensions in Modern Visual Culture: Anti-Semitism, Assimilation, Affirmation* (Waltham, MA: Brandeis Univ., 2010). His current projects include a study of the importance of religious heritage on left-leaning Jewish American artists between 1880 and 1940 and also the ways contemporary artists explore Jewish themes.

**DAVID E. KAUFMAN** holds the Florence and Robert Kaufman Chair in Jewish Studies at Hofstra University. He was previously Associate Professor of American Jewish History at the Hebrew Union College in Los Angeles. Dr. Kaufman has published numerous articles on the social, religious, and architectural history of the American synagogue; as well as a major study of early twentieth-century Jewish communal institutions, *Shul with a Pool: The "Synagogue-Center" in American Jewish History* (Hanover,

NH: Brandeis Univ./UPNE, 1999). His most recent book is a study in American Jewish popular culture—*Jewhooing the Sixties: American Celebrity and Jewish Identity* (Waltham, MA: Brandeis Univ./UPNE, 2012) surveys Jewish celebrity culture of the early 1960s, highlighting four famous Jews of the time: Sandy Koufax, Lenny Bruce, Bob Dylan and Barbra Streisand.

**MARCIE KAUFMAN** is an artist, curator and Jewish Art professional. She earned her BA in Art History from the University of Southern California and MFA in Photography and Painting from Claremont Graduate University. Her artwork is exhibited regularly throughout Los Angeles and USC recently acquired nine of her paintings for its new Health Sciences Building. She curated exhibitions and coordinated public programs at the Skirball Cultural Center, produced the Jewish Federation's Tel Aviv/Los Angeles Partnership's visual and performing arts exchange, and edited *A Gathering of Sparks: The Jewish Artists Initiative 2004–2011* (Los Angeles: Jewish Artists Initiative of Southern California, 2011). Currently, she works at the Foundation for Jewish Culture in New York City.

**DANIEL H. MAGILOW** is Associate Professor of German at the University of Tennessee, Knoxville. He is the author of *The Photography of Crisis: The Photo Essays of Weimar Germany* (Univ. Park, PA: Penn State Univ., 2012), editor and translator of *In Her Father's Eyes: A Childhood Extinguished by the Holocaust* (New Brunswick, NJ: Rutgers Univ., 2008) and co-editor of *Nazisploitation!: The Nazi Image in Low-Brow Cinema and Culture* (New York: Continuum, 2011). He has also published numerous articles and book chapters about various forms of Holocaust representation, including photography from the Warsaw Ghetto, the "paper clip" memorial in Whitwell, Tennessee, and the Holocaust memorial compendia known as *yizker* books.

**RICHARD MCBEE** is a painter of Biblical subject matter and writer on Jewish Art. He was Program Director of the Alliance of Figurative Artists in the 1980's and member of the Biblical Painters Group. In 1991 he helped found the American Guild of Judaic Art. Since 2000 he has written a column on the Jewish Arts for the Jewish Press and continues to exhibit paintings and curate Jewish art exhibitions. In 2008 he was a founding member of the Jewish Art Salon and has been cited in Matthew Baigell's *Jewish Art in America* (2006).

**RUTH WEISBERG**, artist, Professor and former Dean of the Roski School, USC, received the Foundation for Jewish Culture's 50th Anniversary Cultural Achievement Award 2011, the Art Leadership Award, National Council of Art Administrators and the Women's Caucus for Art Lifetime Achievement Award, 2009, Doctor of Humane Letters, honoris causa, Hebrew Union College, 2001, College Art Association Distinguished Teaching of Art Award 1999, Visiting Artist, American Academy in Rome 2011, 1995,

1994, and 1992. Weisberg has had over eighty solo and 185 group exhibitions, including major exhibitions at the Norton Simon Museum, Pasadena and a retrospective at the Skirball Museum, Los Angeles. Her work is included in sixty major Museum collections including The Art Institute of Chicago; The Biblioteque Nationale of France, Paris; Istituto Nationale per la Grafica, Rome; The Los Angeles County Museum of Art; The Metropolitan Museum of Art; the Whitney Museum of American Art, New York; and the National Gallery, Washington, DC.

**BRUCE ZUCKERMAN** is the Myron and Marian Casden Director of the Casden Institute and a Professor of Religion at USC, where he teaches courses in the Hebrew Bible, the Bible in western literature, the ancient Near East, and archaeology. A specialist in photographing and reconstructing ancient texts, he is involved in numerous projects related to the Dead Sea Scrolls. On ancient topics, his major publications are *Job the Silent: A Study in Biblical Counterpoint* (New York: Oxford Univ., 1991) and *The Leningrad Codex: A Facsimile Edition* (Grand Rapids, MI: Eerdmans; Leiden: Brill, 1998), for which he and his brother Kenneth did the principal photography. Zuckerman also has a continuing interest in modern Jewish thought, often looking at modern issues from an ancient perspective. He most recently co-authored *Double Takes: Thinking and Rethinking Issues of Modern Judaism in Ancient Contexts* (Lanham: MD: Univ. Press of America) with Zev Garber and contributed a chapter to Garber's book, *Mel Gibson's Passion: The Film, the Controversy, and Its Implications* (West Lafayette, IN: Purdue Univ., 2006).

# The USC Casden Institute for the Study of the Jewish Role in American Life

The American Jewish community has played a vital role in shaping the politics, culture, commerce and multiethnic character of Southern California and the American West. Beginning in the mid-nineteenth century, when entrepreneurs like Isaias Hellman, Levi Strauss and Adolph Sutro first ventured out West, American Jews became a major force in the establishment and development of the budding Western territories. Since 1970, the number of Jews in the West has more than tripled. This dramatic demographic shift has made California—specifically, Los Angeles—home to the second largest Jewish population in the United States. Paralleling this shifting pattern of migration, Jewish voices in the West are today among the most prominent anywhere in the United States. Largely migrating from Eastern Europe, the Middle East and the East Coast of the United States, Jews have invigorated the West, where they exert a considerable presence in every sector of the economy—most notably in the media and the arts. With the emergence of Los Angeles as a world capital in entertainment and communications, the Jewish perspective and experience in the region are being amplified further. From artists and activists to scholars and professionals, Jews are significantly influencing the shape of things to come in the West and across the United States. In recognition of these important demographic and societal changes, in 1998 the University of Southern California established a scholarly institute dedicated to studying contemporary Jewish life in America with special emphasis on the western United States. The Casden Institute explores issues related to the interface between the Jewish community and the broader, multifaceted cultures that form the nation—issues of relationship as much as of Jewishness itself. It is also enhancing the educational experience for students at USC and elsewhere by exposing them to the problems—and promise—of life in Los Angeles' ethnically, socially, culturally and economically diverse community. Scholars, students and community leaders examine the ongoing contributions of American Jews in the arts, business, media, literature, education, politics, law and social relations, as well as the relationships between Jewish Americans and other groups, including African Americans,

Latinos, Asian Americans and Arab Americans. The Casden Institute's scholarly orientation and contemporary focus, combined with its location on the West Coast, set it apart from—and makes it an important complement to—the many excellent Jewish Studies programs across the nation that center on Judaism from an historical or religious perspective.

For more information about the USC Casden Institute,
visit www.usc.edu/casdeninstitute, e-mail casden@usc.edu,
or call (213) 740-3405.